15 minute
Drawing
ONE-LINE DRAWING

Heinke Nied

Walter Foster

Quarto.com • WalterFoster.com

© 2023 Quarto Publishing Group USA Inc.
Backgrounds and borders © Shutterstock.
The original German edition was published as *One Line – Zeichnen in einer Linie.*
Copyright © 2021 frechverlag GmbH, Stuttgart, Germany (www.topp-kreativ.de)
This edition is published by arrangement with Anja Endemann, ae Rights Agency,
Berlin, Germany.

First published in 2023 by Walter Foster Publishing, an imprint of The Quarto Group,
100 Cummings Center, Suite 265D, Beverly, MA 01915, USA.
T (978) 282-9590 **F** (978) 283-2742

Walter Foster Publishing titles are also available at discount for retail, wholesale,
promotional, and bulk purchase. For details, contact the Special Sales Manager by email
at specialsales@quarto.com or by mail at The Quarto Group, Attn: Special Sales Manager,
100 Cummings Center, Suite 265D, Beverly, MA 01915, USA.

27 26 25 24 23 1 2 3 4 5

ISBN: 978-0-7603-8328-5

Artwork and drawings by Heinke Nied
Translation by Hazel Blumberg-McKee

Printed in China

TABLE OF CONTENTS

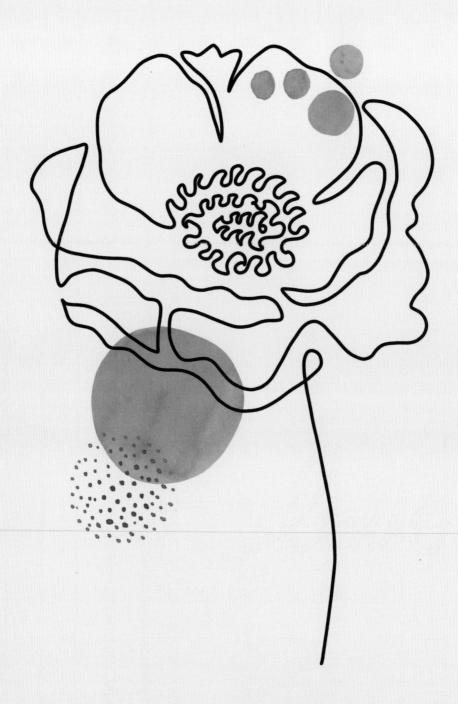

Introduction

Hello! I'm so glad you're here and that you've decided to try one-line drawing! Together we'll dedicate ourselves to this fun new art form. This book reveals my passion for drawing and will guide you as you begin your own journey with drawing using a single continuous line.

Are you wondering how I became interested in one-line drawing? Well, for a long time, I was in search of a freer drawing technique, one that would bring excitement into my everyday life. When I started drawing with one line, it was like a whole new world opened up for me!

I started out drawing in my sketchbook because I always had that and a fineliner pen with me. At first it was just a hobby—something fun and relaxing. Over time, I began adding watercolors as well. I still love the interplay of soft and glowing colors that feature the most minimal of lines.

Later, I started building line art into my courses and workshops. What I had at first viewed only as a relaxation technique developed quickly into real drawing projects, such as postcards, pictures, and gift tags. Gradually, I combined watercolors and calligraphy with my line art, and I found that this combination worked wonderfully for a new, modern look.

The positive feedback from those who'd taken my courses and workshops motivated me to continue with this technique and create instructions for individual projects. In this book, I show you how to create your own one-line drawings step by step and then turn them into complete, polished artwork—in just 15 minutes!

For me, one-line art isn't just a trend but rather a totally new form of drawing and an artistic representation of my surroundings. I wish you much joy with one-line drawing!

WHAT IS ONE-LINE DRAWING?

One-line drawing is much more than just a trend! With this technique, you draw your subject using just one single line, without breaking the line or starting a new one on the same page. You can draw any subject using this technique. How you draw those subjects is entirely up to you. Whether you like a minimalist, playful, or abstract style, there are tons of opportunities for you to add your own creativity to your artwork. You can also use any drawing tool you like, whether it's a felt-tipped pen, pencil, chalk, brush pen, or ballpoint or fountain pen.

- One-line drawing is an excellent exercise for training your hand's muscle memory, as well as hand-eye coordination.

- In addition, this type of drawing enhances your observational abilities. Over time, you will learn to pick out the most important lines of your motif very quickly. With a little practice, this gets easier and easier so that you can complete a drawing in seconds or minutes.

- You need very little time to create a one-line sketch, and there are few materials needed. A sheet of paper and a writing instrument are enough to get you going.

- Drawing in one line is very meditative and relaxing. It will further your creativity and improve your drawing style. If you let it totally and completely take over, you can get into a regular drawing flow.

- One-line drawings are a wonderful opportunity to find your own art style. The absolute best part: it's a lot of fun!

Originally thought of as only a
drawing exercise, one-line drawing
has evolved into not just a form of art
but also a unique new way of drawing.
One-line drawings look especially
artistic and harmonious, as well as
new and fresh, when color is added.
Watercolor and gouache work well
here, as does calligraphy.

DRAWING TIPS

The charm of a one-line drawing is that you don't pick up your drawing tool from the drawing surface until your picture is finished. At first, this may be somewhat strange, but with time, your brain and your hands will get used to it, and this technique will feel natural to you.

When you're just starting out, warm-up exercises will help you a lot. You can find some suggestions on page 12. I suggest practicing these many times. Your line may look thicker or thinner in places, but you should avoid breaking the line until you finish your artwork. Don't use an eraser—embrace any imperfections.

My Tips for You

- Grab your favorite drawing or writing tool, and warm up by drawing waves, circles, loops, hearts, or spirals. This part is really important: make sure to vary the direction of your drawing hand. Draw a spiral not just toward the right but also to the left, and make wavelike lines from left to right as well as from the top down. This will help you get a feel for one-line drawing and will give not just your hand but also your brain a chance to get used to this new-to-you style of drawing.

- Repetition is very, very important! Draw your motif again and again to really familiarize yourself with this technique.

- Make a one-line drawing in your journal or sketchbook every single day. This helps you stay in practice, and it's also wonderfully relaxing!

- Draw without judging yourself. Your skills will improve over time!

From 1 to 3: Difficulty Scale

So you can easily see which projects are best for beginners and which ones to do once your skills are more advanced, I've added a difficulty scale to each project.

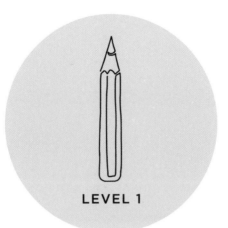

LEVEL 1

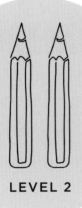

LEVEL 2

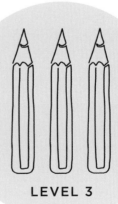

LEVEL 3

TOOLS & MATERIALS

You can use all sorts of writing and drawing tools for one-line drawing. I like to use a pen with black ink or a pencil to draw, but you can use anything you like. Feel free to add color as well!

FINELINER PENS

Fineliners come in many colors and in various types according to thickness. I like to use the following pens:
• Faber-Castell Ecco Pigment Fineliner in black with 0.3 or 0.6 tip
• Staedtler Pigment Liner in black with 0.8 tip
• Faber-Castell Pitt Artist Pen with 0.7 medium tip
• Molotow One4All Acrylic Twin Marker in white with 4 and 5mm tips

PENCILS

A pencil with a medium degree of hardness, such as an HB, is good for sketching.

BRUSH PENS

A brush pen allows you to build thicker and thinner lines into your artwork, depending on the amount of pressure you apply to the flexible tip. I like to use the Faber-Castell Pitt Artist Pen Brush B in black.

PAPER

You can use any kind of paper for one-line drawing. Use watercolor paper if you'd like to add paint to your pieces. It's thicker than normal drawing paper. I like to use Hahnemühle watercolor with a weight of 300 gsm.

FOUNTAIN PENS

Fountain pens are also good for one-line drawings. Make sure you use waterproof ink if you want to incorporate watercolor backgrounds.

WATERPROOF FELT PENS

With a waterproof felt pen, you can draw on surfaces besides paper, such as a wooden board, for example. I like to use the Edding 3000 permanent marker.

PAINT & PAINTBRUSHES

Watercolors work superbly with one-line art. Their luminosity adds a particular tension and harmonious mood to art. Acrylic and gouache look somewhat flatter; you can create wonderful abstract backgrounds for your one-line drawings using these paints.

When adding paint to your drawing, it's best to use a round brush. You may want to purchase two excellent brushes in a set of two sizes—you'll enjoy yourself more if you don't have to keep rinsing your brushes!

WARMING UP

Begin by loosening up your wrists. Draw simple, wavelike lines, loops, and abstract forms. Change the direction of your drawing hand again and again (see "Drawing Tips" on page 8). These exercises will train your wrist to create a fluid straight line. Using a spiral shape, you can develop your first flower, as shown on page 13. Repeat the warm-up exercises until your hand moves loosely.

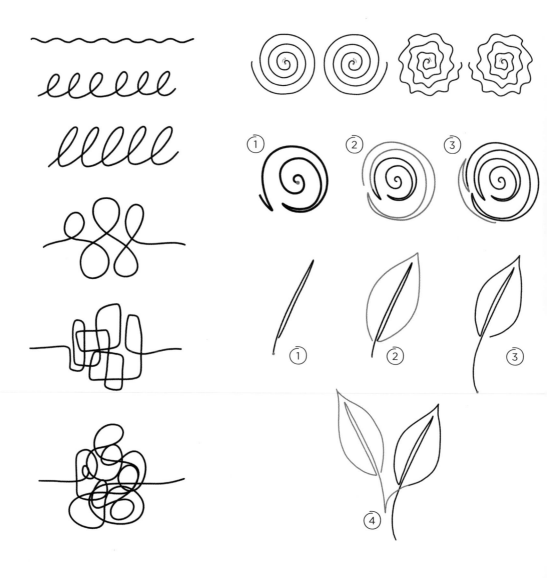

YOUR FIRST ROSE

Have you practiced making spirals and individual leaves? Then it's time for your first flower! To create this rose, simply combine a wavelike spiral with wavelike leaf outlines.

Repeat this pattern again and again. You'll see that new variations will occur automatically. Every rose will look individual and different. That is exactly what's so special about one-line art!

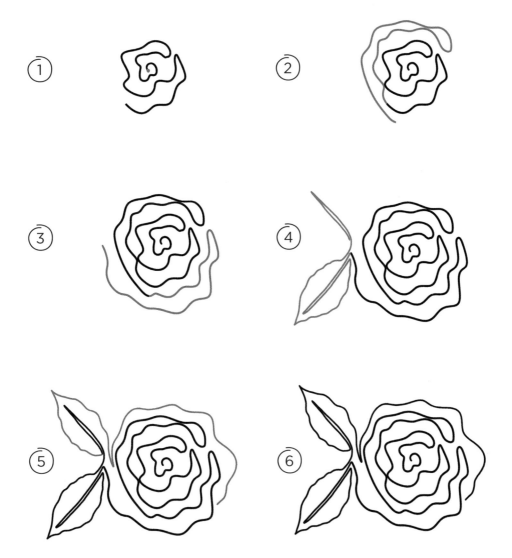

Flowers
& Leaves

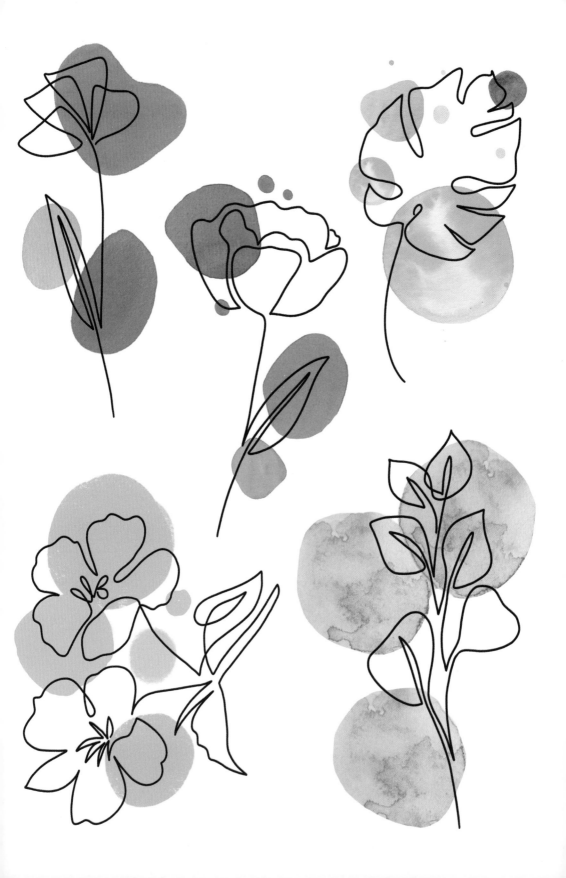

A SIMPLE FLOWER

Who doesn't like a little flower and a nice greeting? Draw the simple form of a flower and add a little color, and just like that, your first one-line drawing is ready to be added to a gift tag or card to a loved one!

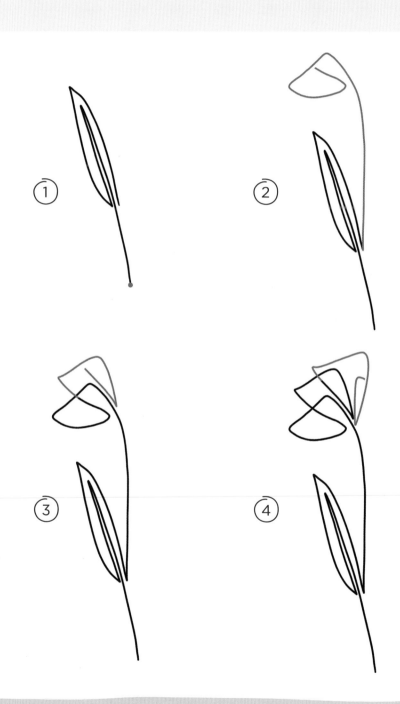

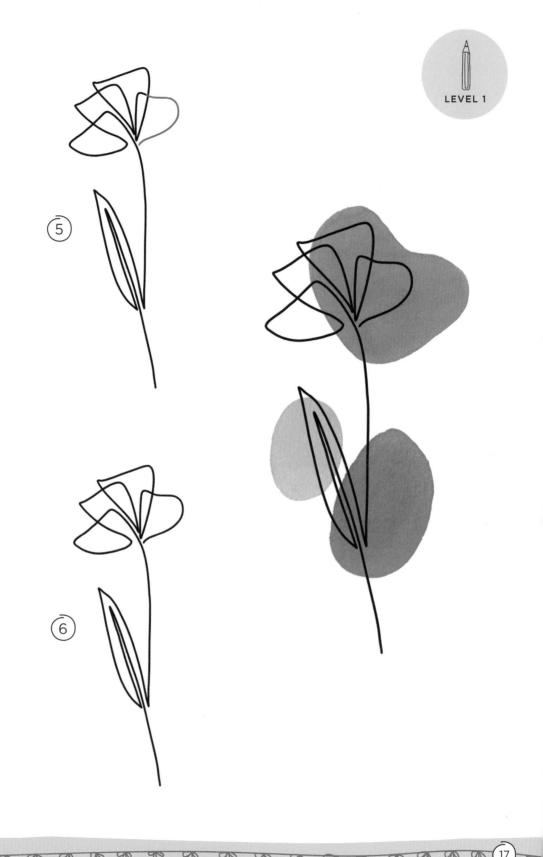

⑤

⑥

PEONY

Peonies bloom with the warm rays of the sun in springtime.
Their time is short, but that only makes their profusion of blooms
that much more infatuating. Once a year, they reward us with their
seductive smell and bloom in many colors.

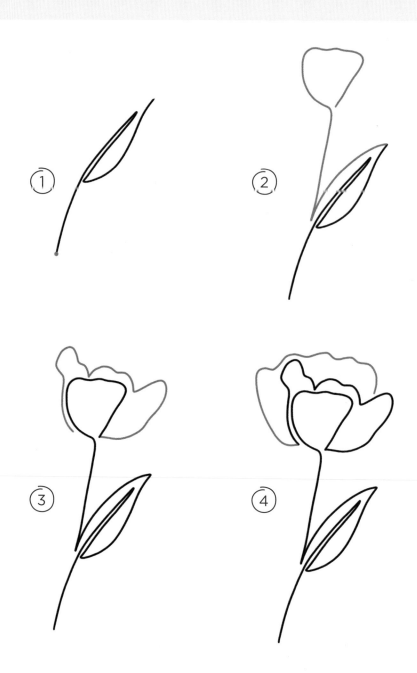

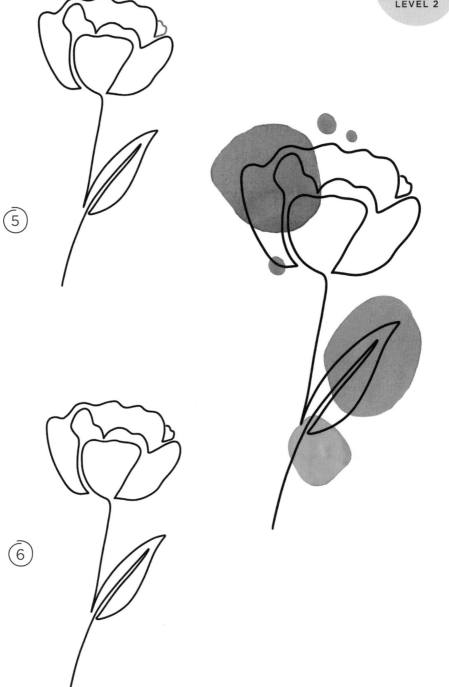

5

6

MONSTERA LEAF

The enormous, striking leaves of the Monstera plant have been popular for a number of years. You can see them featured on textiles, pictures, pillows, and even carpets. The plant, which is also called a Swiss cheese plant, is native to Central and South America.

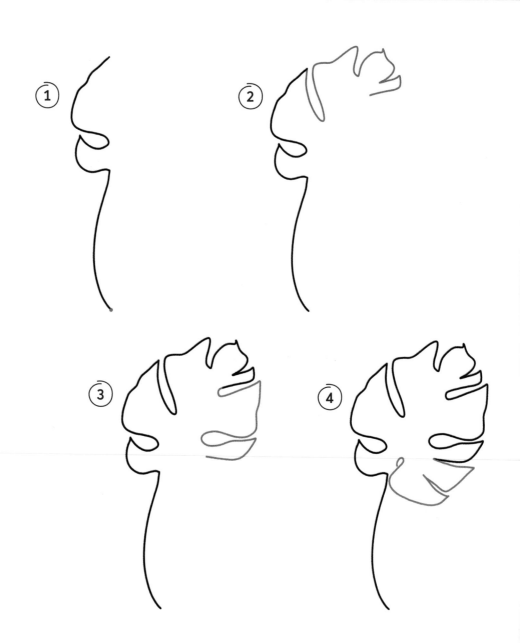

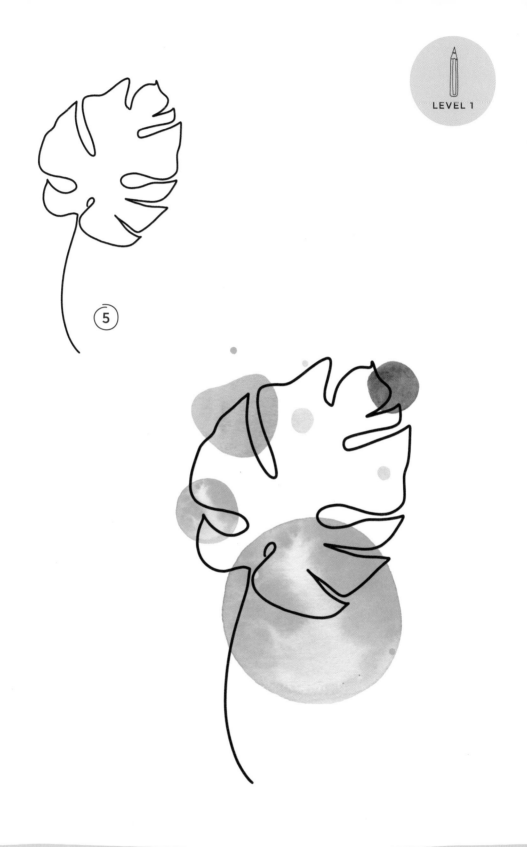

5

EUCALYPTUS LEAF

The eucalyptus has also blossomed into a trendsetter.
It likes to show off its delicate loveliness as a table decoration,
in bouquets, or as part of a wreath, especially during the holidays.

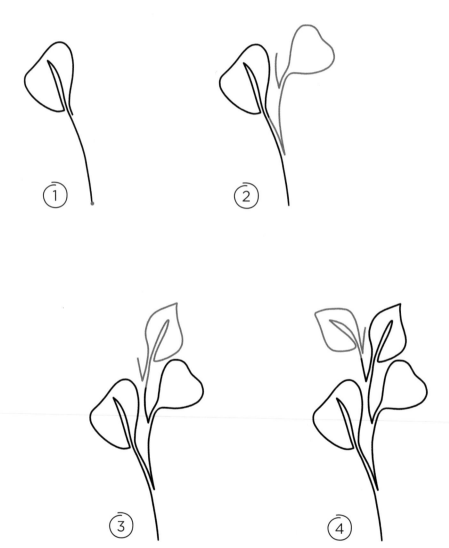

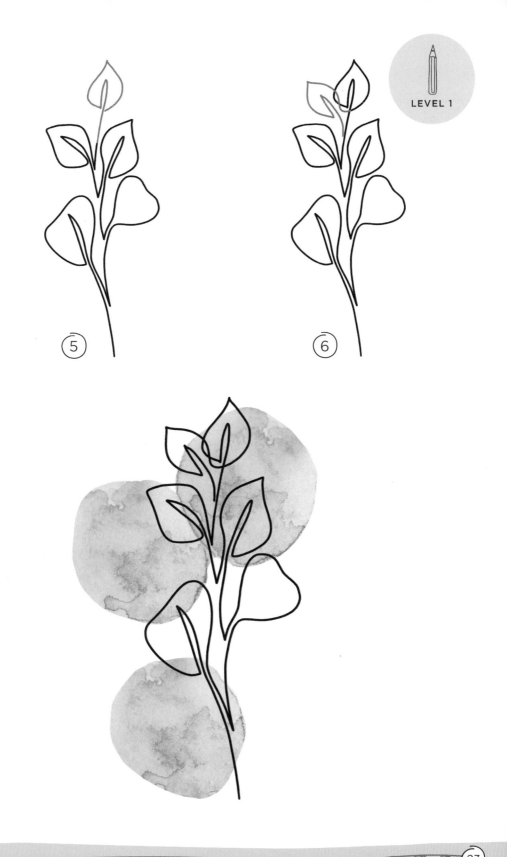

⑤

⑥

ANEMONE

These graceful cut flowers look wonderful in any vase. Their name comes from a Greek myth and means "daughter of the wind."

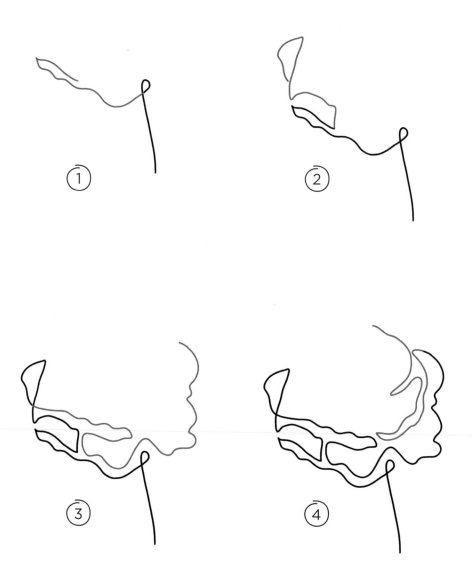

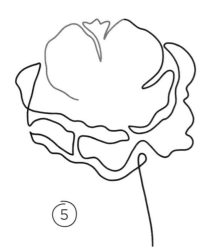

⑤

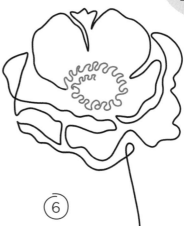

⑥

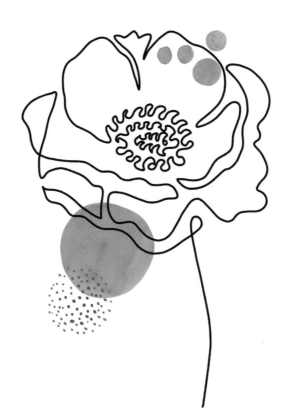

THE LOVE OF FLOWERS

Quiet little moments can help us understand what happiness means
and what is really important in life. By walking quietly through a meadow
filled with flowers, a new view of the world may open up to you.
This is a great source of inspiration for artists.

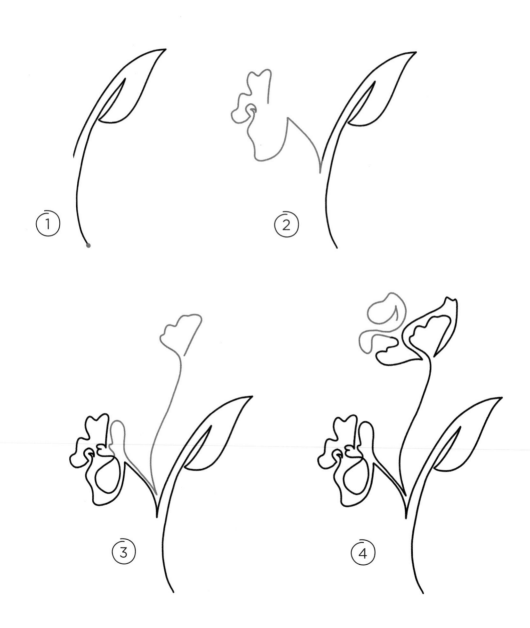

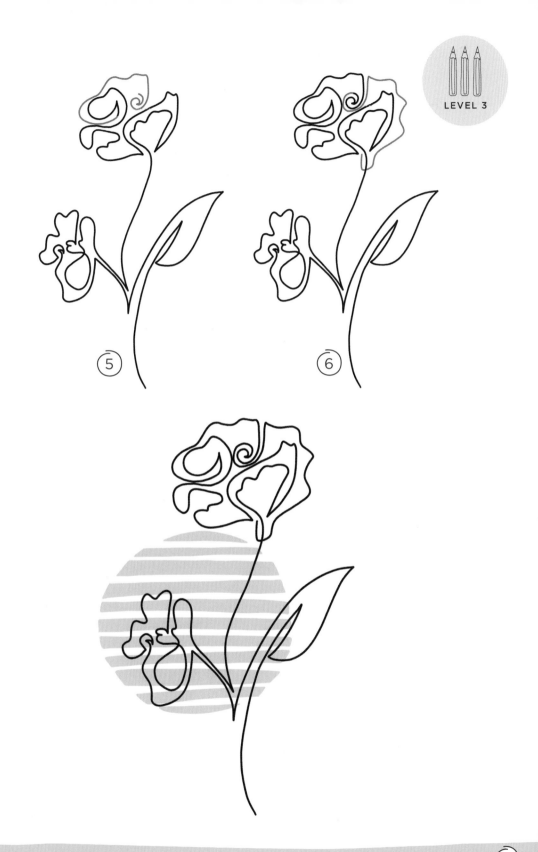

⑤

⑥

CHERRY BLOSSOM

Every year I look forward to viewing the cherry trees' lovely light-pink flowers. When seen against a blue sky, this view embodies spring for me.

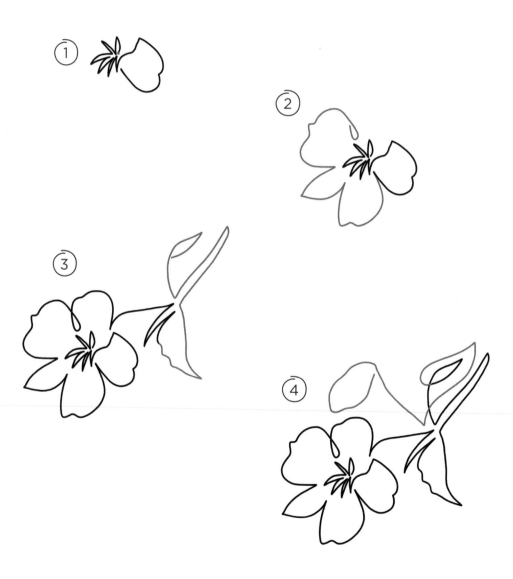

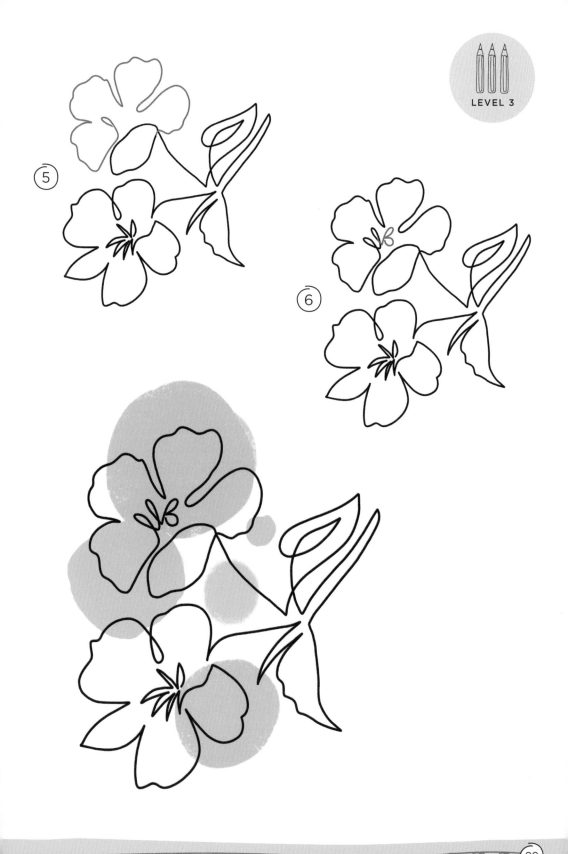

⑤

⑥

Plants

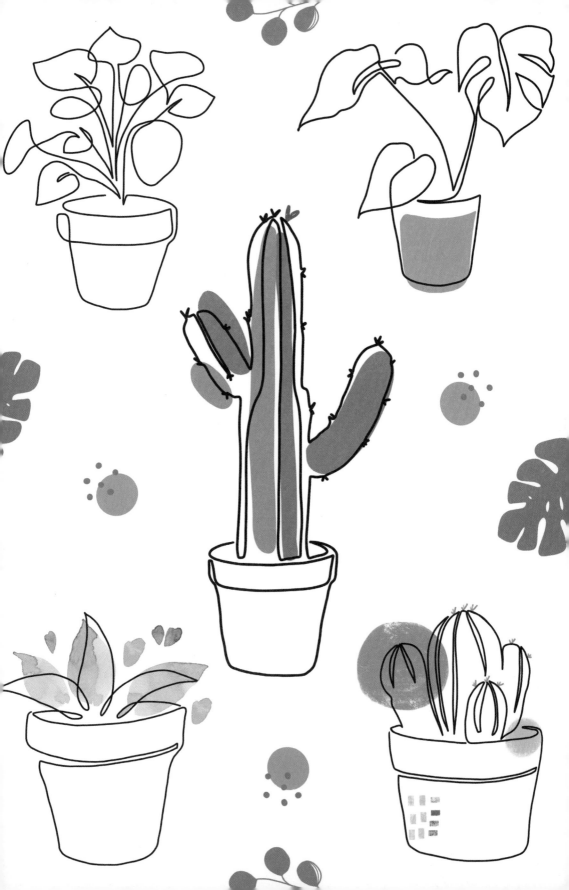

POTTED PLANT

Show your loved ones how much you care by giving them a handmade greeting card featuring a motivational saying and a beautifully drawn plant.

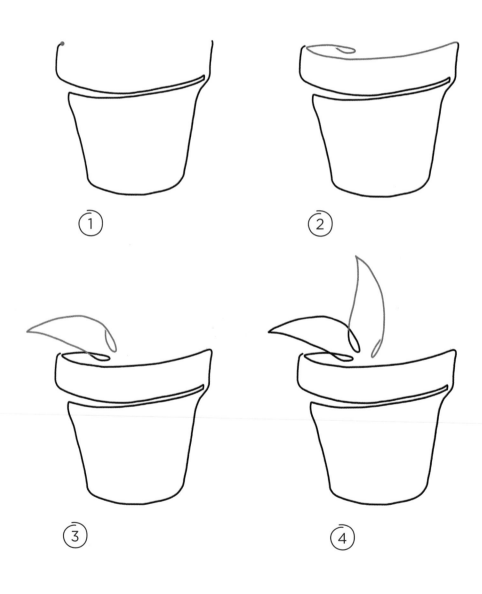

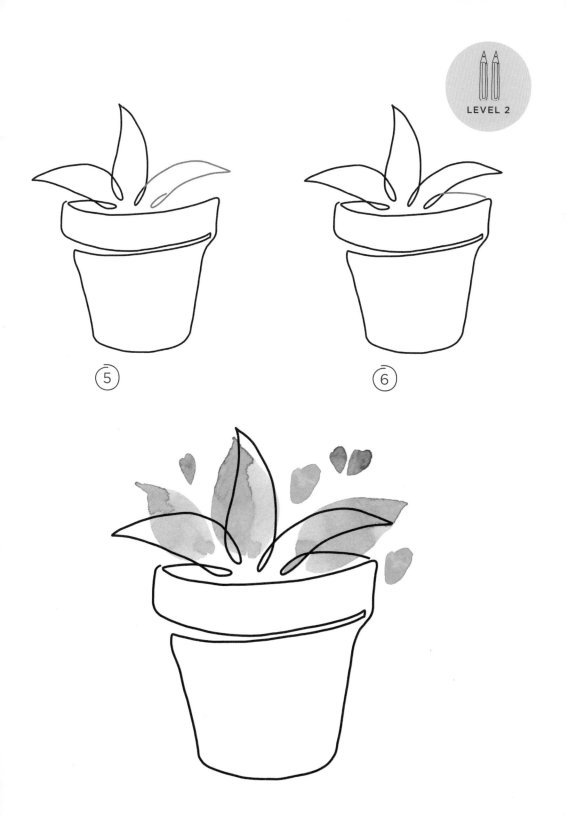

⑤

⑥

CHINESE MONEY PLANT

A beloved and easy-to-care-for plant, the Chinese money plant can bring freshness, nature, and perhaps a little luck into your home.

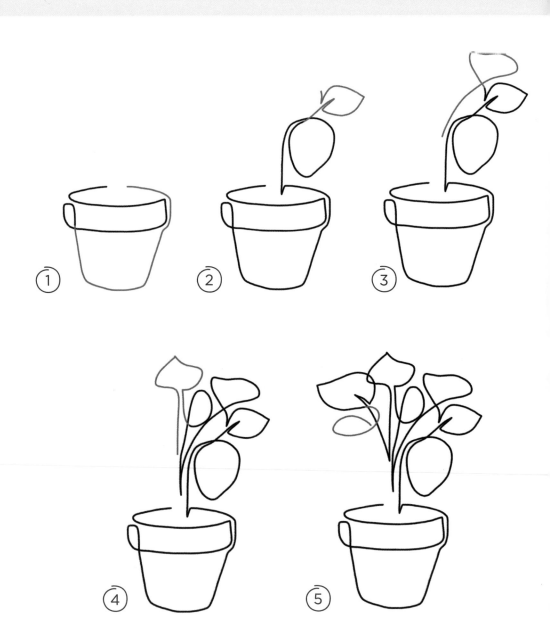

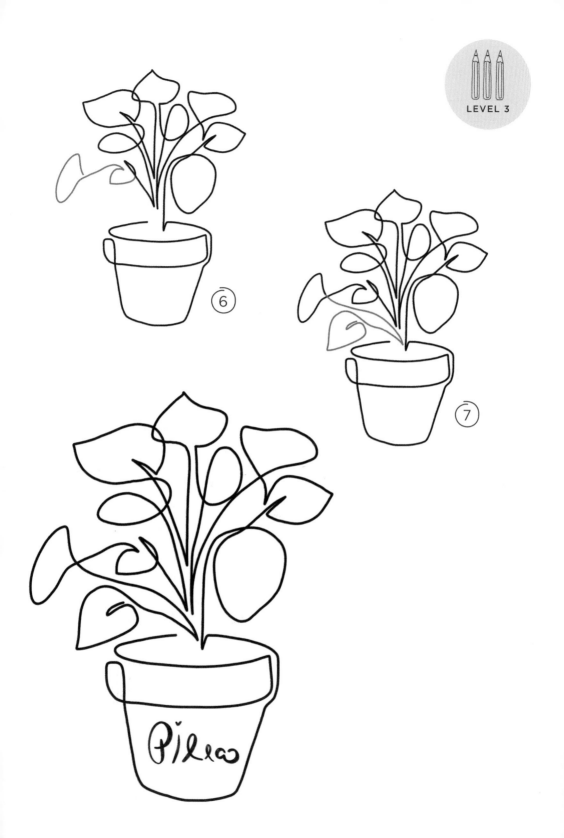

6

7

Pilea

SUCCULENT

Succulents and cacti are popular indoor plants, as well as drawing subjects on posters, notebooks, calendars, and other home décor items.

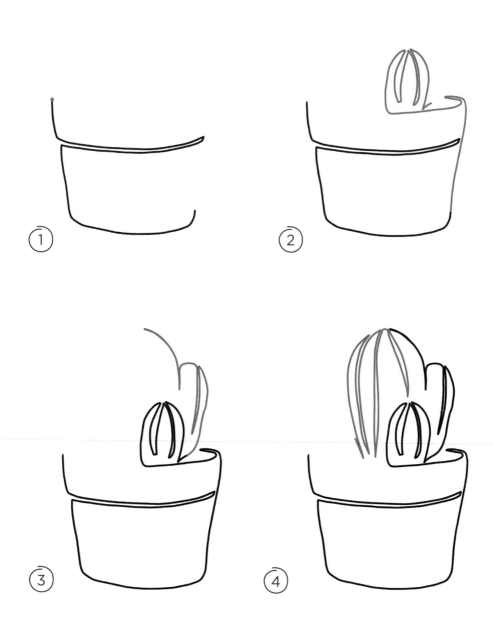

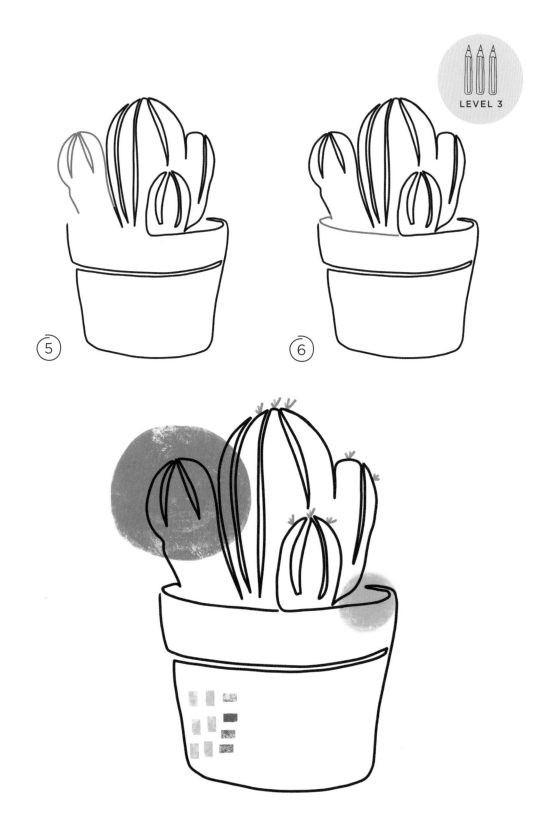

⑤

⑥

HAPPY CACTUS

Cacti are the ingenious survivors of the plant world.
These desert plants have taken over not just a place in my living room
but also a place in my allegorical heart.

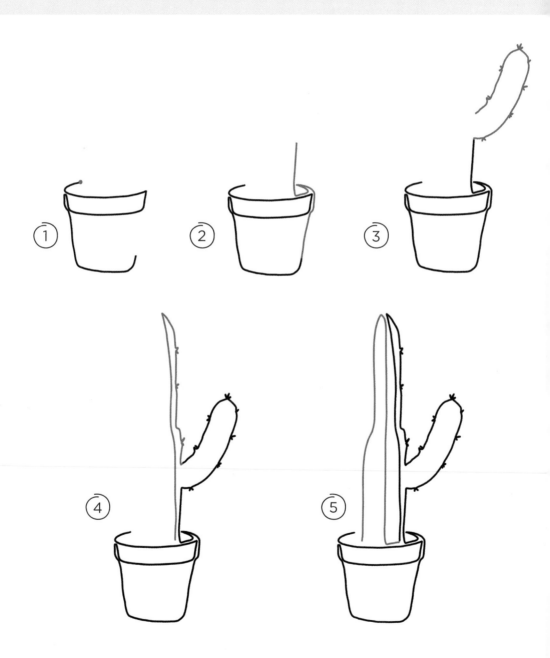

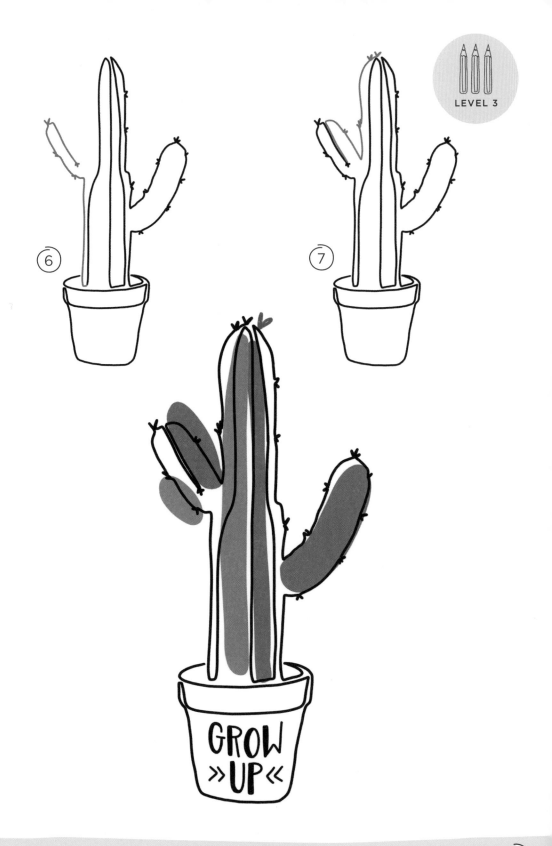

6

7

GROW
»UP«

Faces

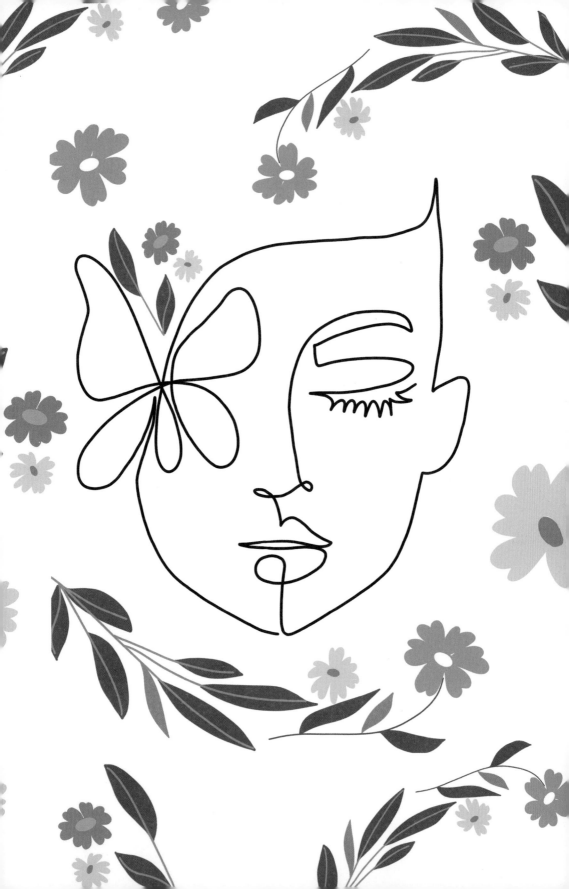

FIRST STEPS

One of the most difficult subjects to draw with a single line is the human face.
Here I've shown you step by step how to draw the facial elements
so that you can incorporate them and draw full faces later on.

NOSE

Begin with the nose. Draw the line from your starting
point down and then slightly to the right into a loop.
Finish by drawing the line down perpendicularly.

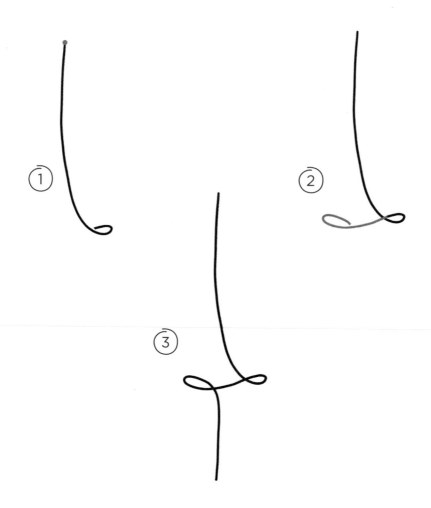

EYE

Begin by drawing a line slightly curved to the right. Take your line back to the uppermost area again and draw a circle. Close the circle parallel to the upper eyelid, and draw the line to the left and down. From there, go back underneath the pupil and then to the right and up. Change the direction of your line and encircle the eye.

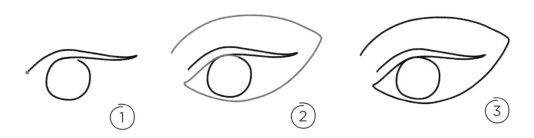

MOUTH

Draw a slightly curved perpendicular line to the right. The line goes from a curved form to the right into a loop. Now move to the left with the next loop. Lengthen the loop to a line to form the lower lip. Draw the line upward, and you've created the upper lip. Shortly before you come back to your beginning point, make your line parallel and sloped downward.

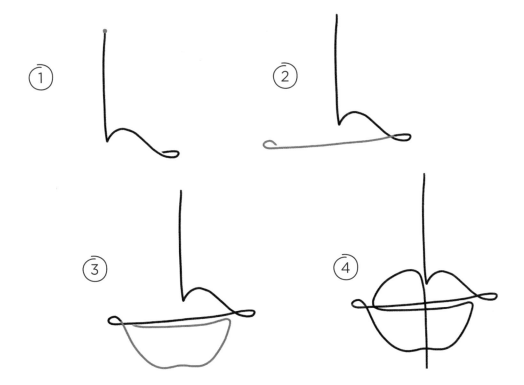

PROPORTIONS

A face is considered proportionate when its elements—such as eyes, nose, and mouth—sit in harmony with each other. To get the proportions right, it helps to have a model to work from.

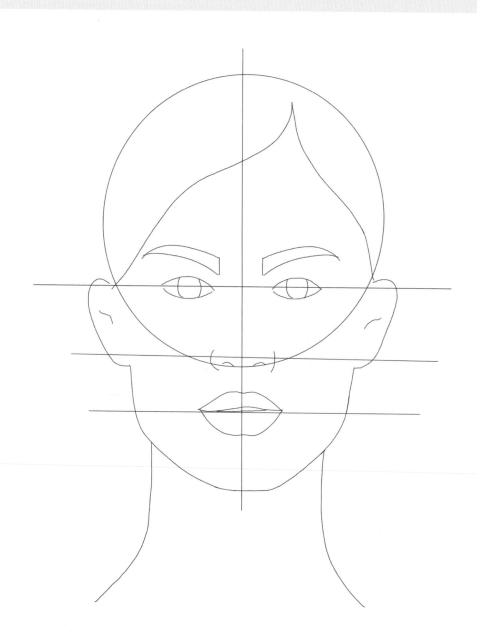

With the help of a model or example, you'll eventually get the proportions memorized. How does that happen? Easy! Copy the example here again and again. That's how you'll imprint the right proportions into your brain and learn how to draw a successful face.

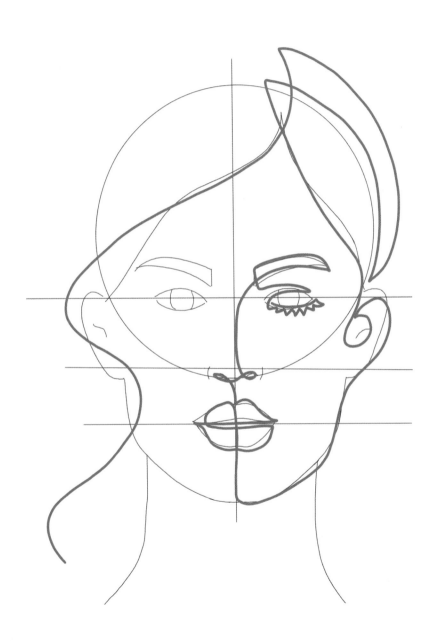

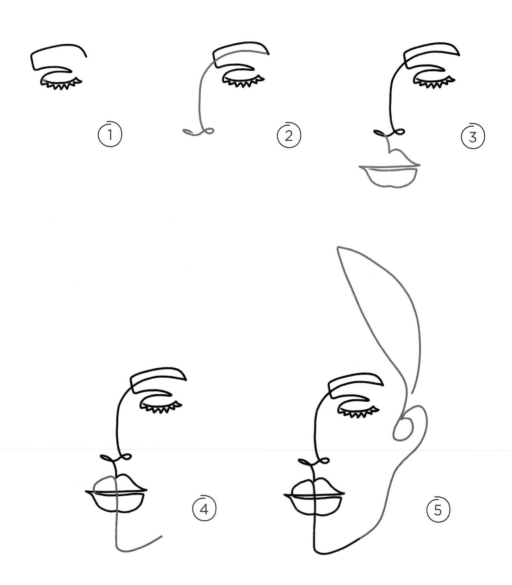

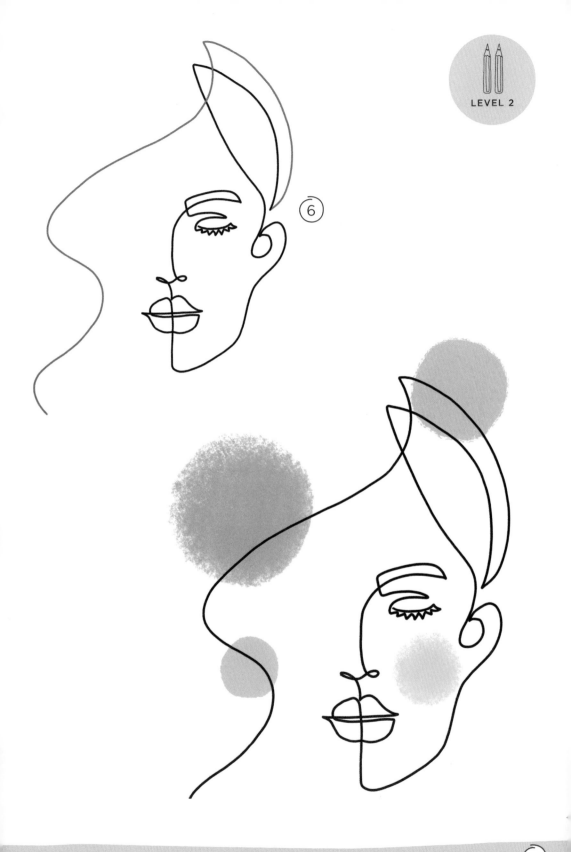

SIMPLY BEAUTIFUL

Often it doesn't take much to create a picture. This face is drawn simply,
and yet it makes a strong impression. With added color, the face opens
into a lovely frame, revealing its entire potential. It's simple and beautiful.

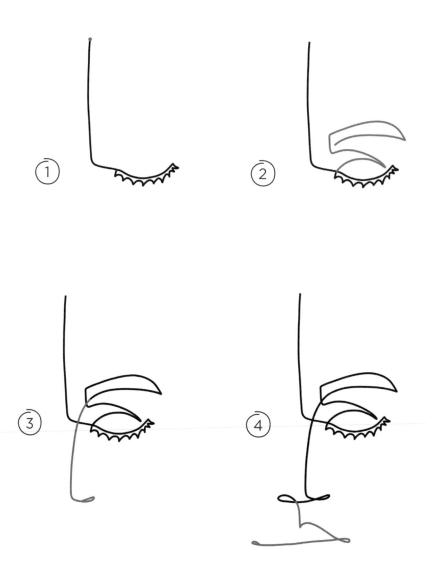

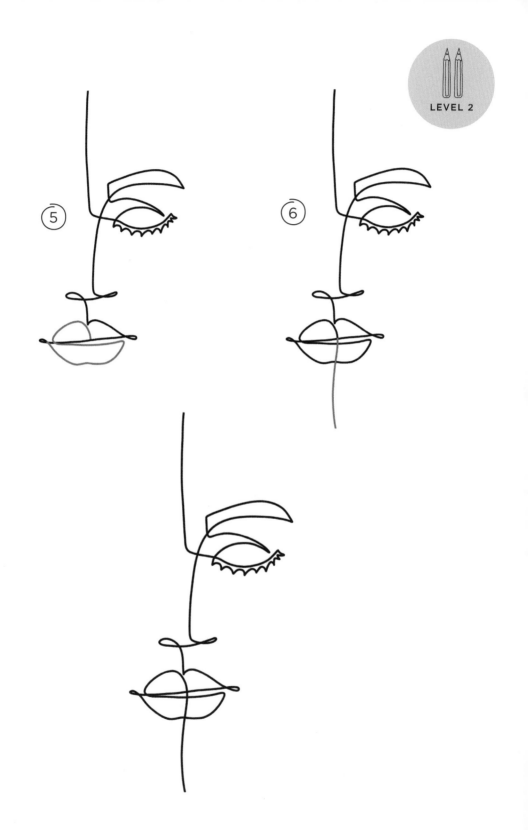

BOHO-STYLE PORTRAIT

You can achieve very different looks depending on the colors you use and any illustrative accessories you work with. Combine a dreamy one-line portrait with any palette and leafy ornamentation you like to create an unconventional boho-style portrait.

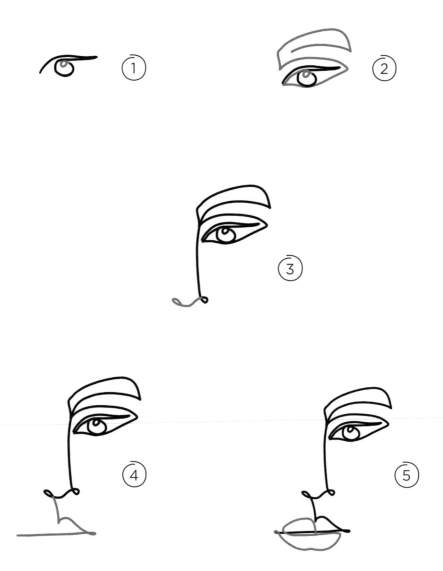

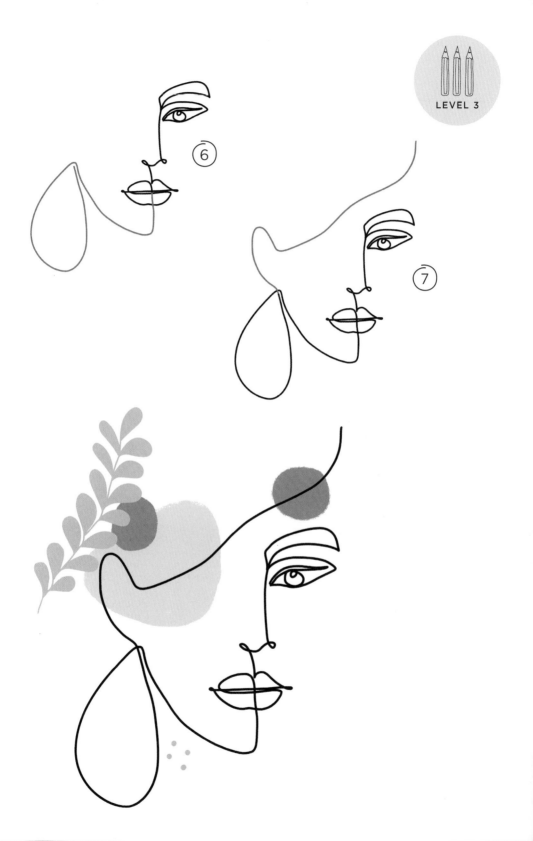

⑥

⑦

FLORALS

It's not always easy to find creative inspiration. When I'm asked where I find my inspiration, my answer is always the same: nature and the seasons. If spring had a face, this is how it would look to me.

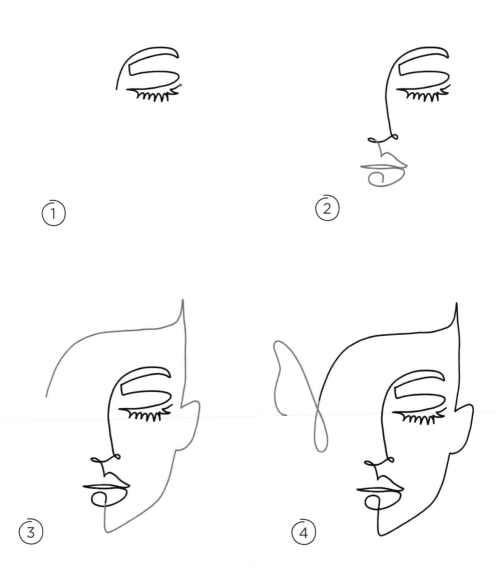

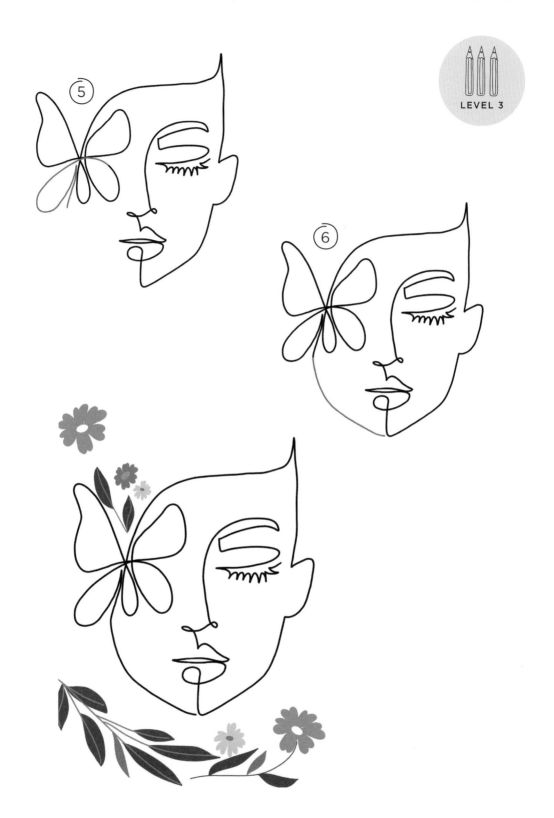

DREAMING

You have many options for setting the mood of your one-line portrait. Perhaps you'd like your portrait to be playful and romantic? Combine soft colors and loosely placed decorative elements in your drawing.

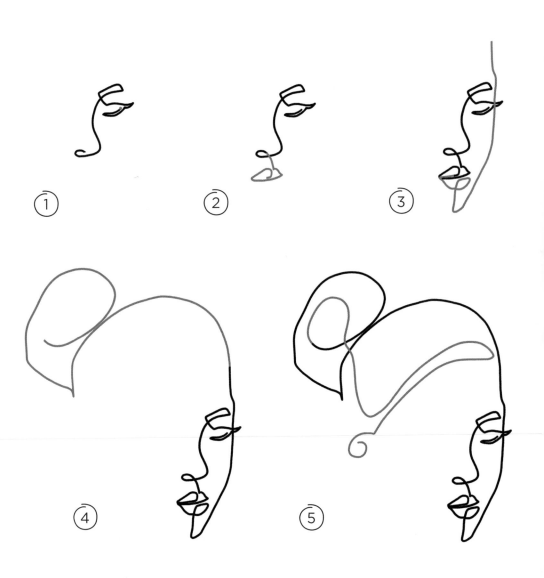

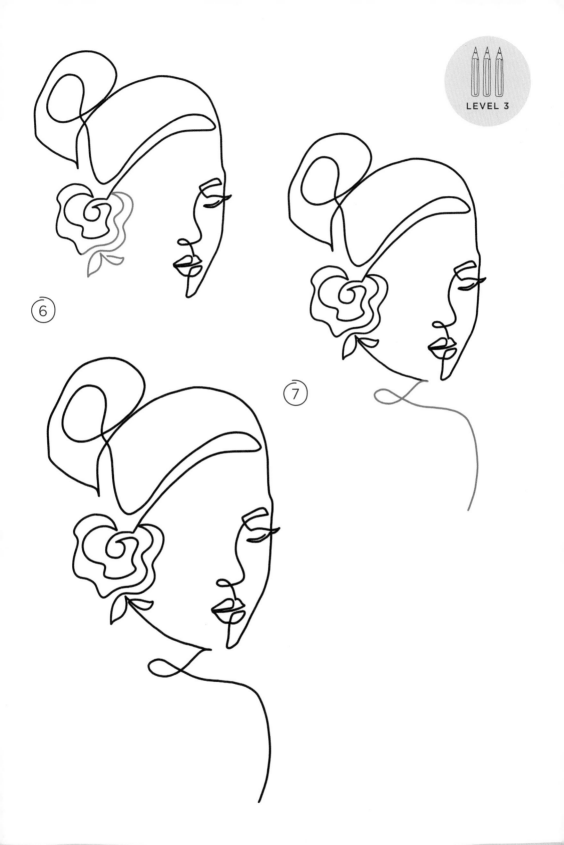

6

7

THE FUTURE IS FEMALE

The graphics, grace, and clear, powerful colors create
the modern look of this portrait.

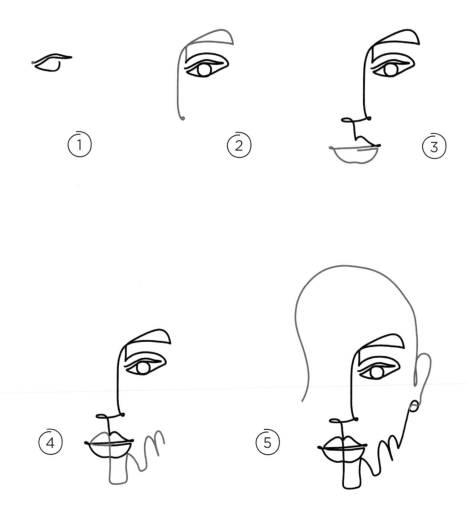

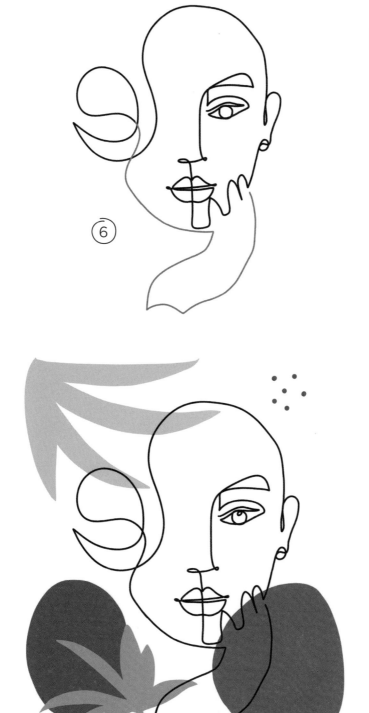

⑥

PROFILE PORTRAIT

Do you have an empty wall in your home? Then trust yourself,
grab a canvas or sheet of paper, acrylic paints, and a writing
instrument with black ink or lead, and get to work. A handmade
picture is much more special than one you've bought!

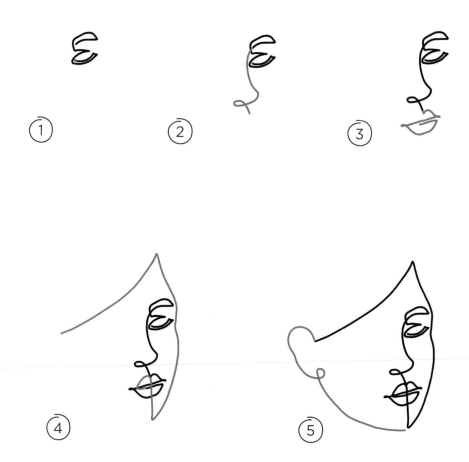

① ② ③ ④ ⑤

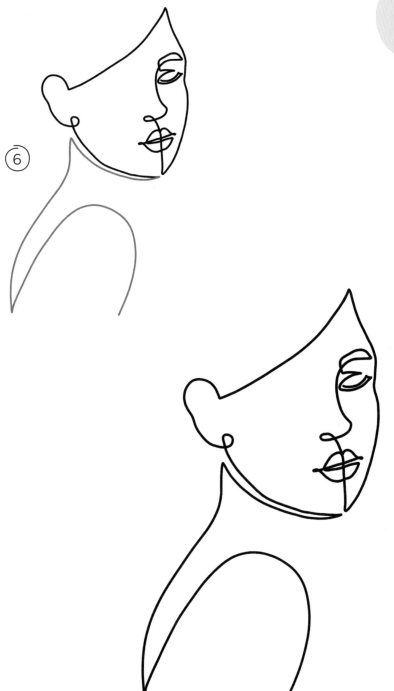

6

STROLLING

A stroll through a field of flowers does the body and soul good. Feel the sun on your face, and let the scent of the flowers tickle your nose. Bees buzz, and moths flutter. Perhaps you'd like to pluck a few flowers?

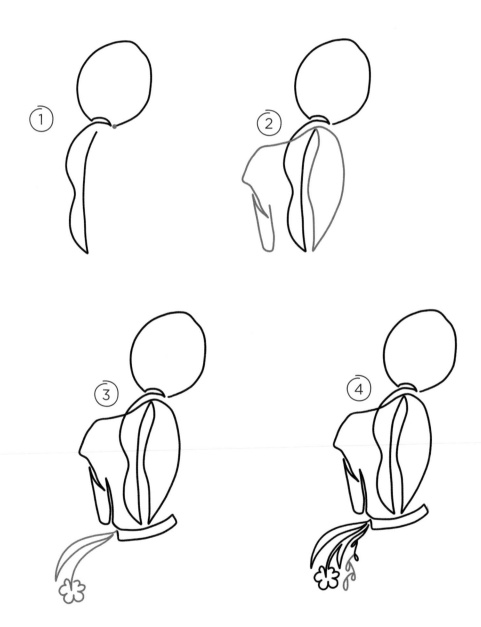

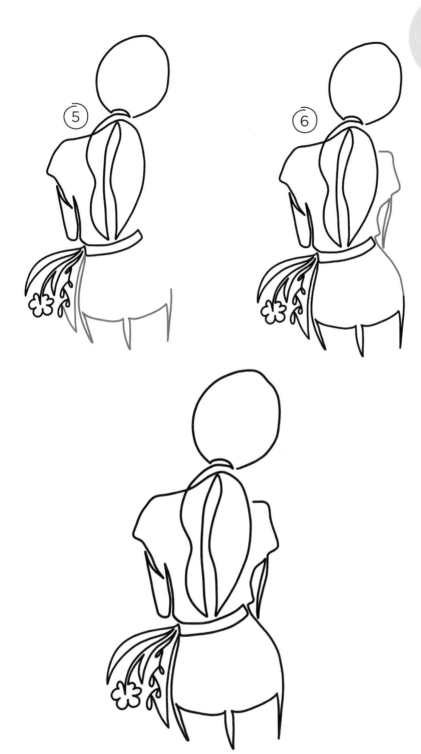

Lifestyle

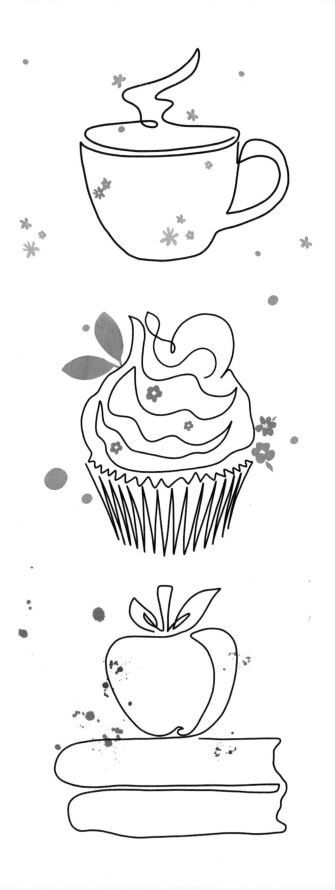

A CUP OF CALM

We all know the feeling. In everyday life, there are so many things to do, and we run from one task to another, hardly having the time for a pause. But you should take the time. In calm lies power. Turn things down a notch during the day, and allow yourself a cup of tea or coffee. For me, that's definitely a cup of calm.

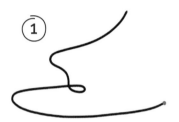

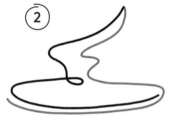

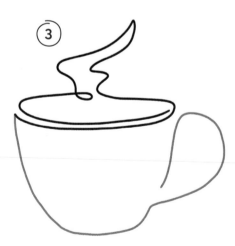

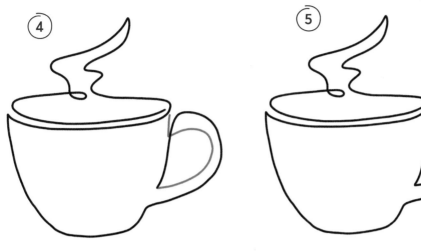

④

⑤

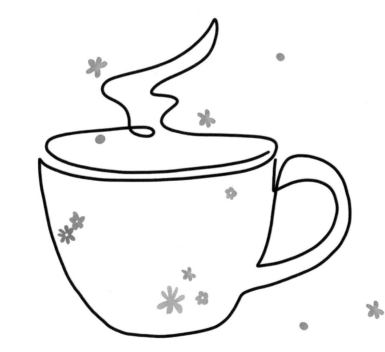

A PLEASANT EVENING

A pleasant get-together with friends, great conversation, good things to eat, and perhaps a bottle of wine—what a wonderful evening!

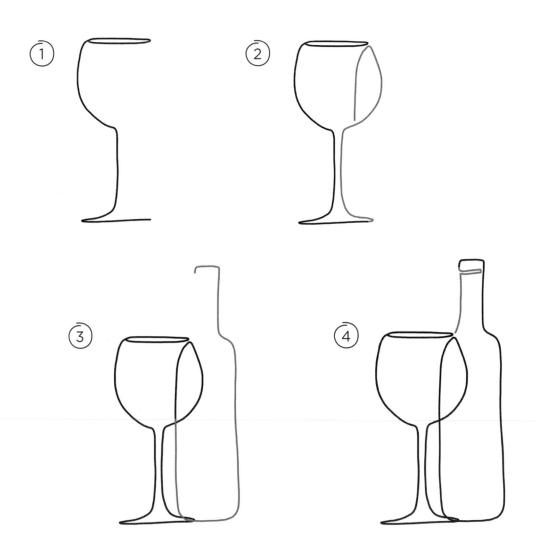

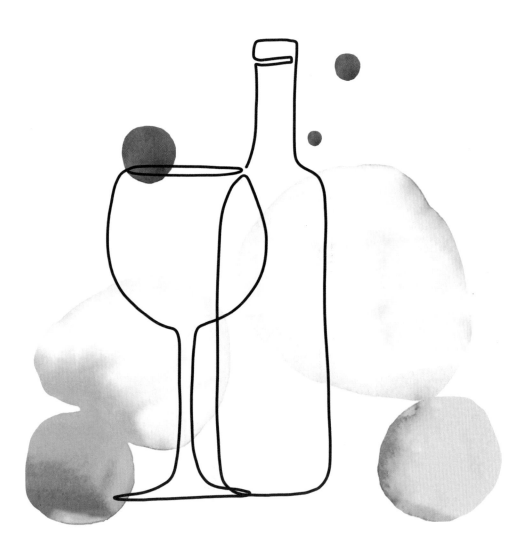

HOME SWEET HOME

Hand-drawn pictures can give your home a bit of personal charm.
My tip for you is to marry your one-line drawing with the color palette
of your home. For the background of this vase drawing, choose only
three colors to create a harmonious and complete picture.

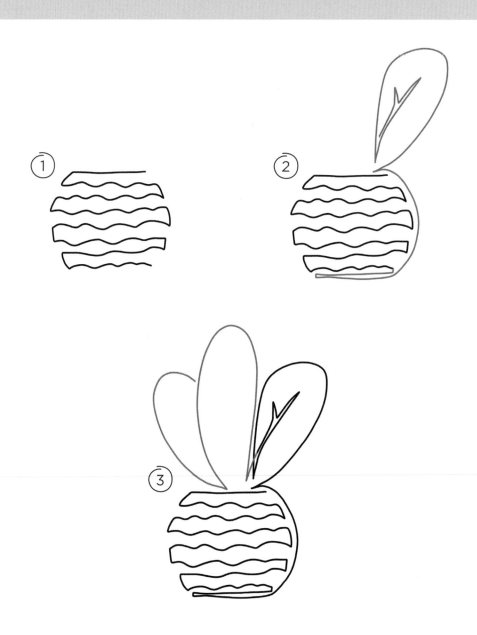

④

BOOKS

For me, a tasty apple and a good book work well together. Why? Both offer pure enjoyment and relaxation. Apples are healthy, and reading reduces stress, encourages concentration, and is just simply fun!

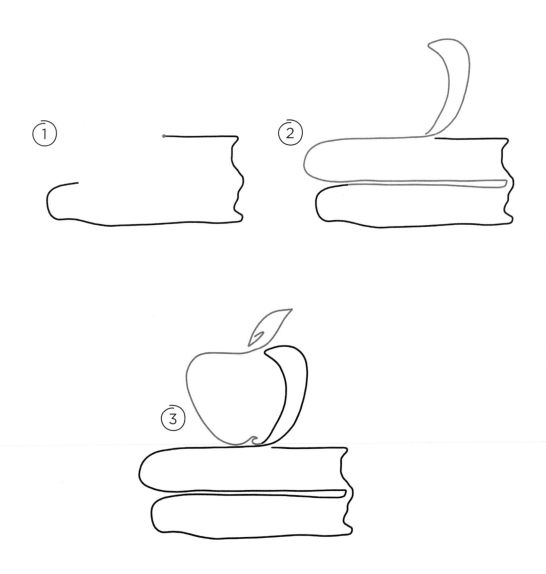

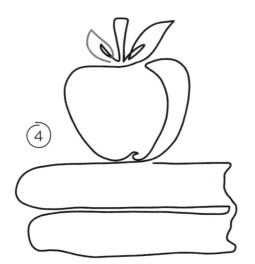

④

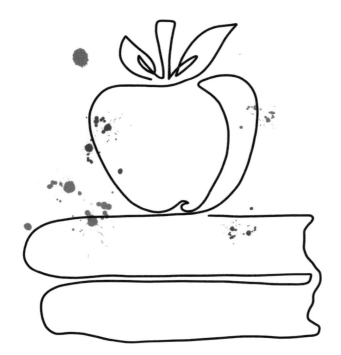

A BIT OF HAPPINESS

As artist Henri Matisse once said, "There are always flowers for those who want to see them."

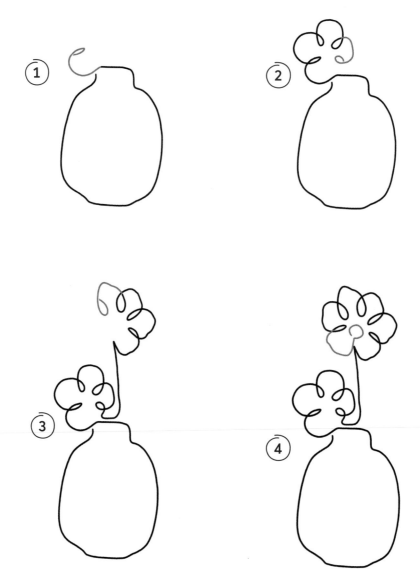

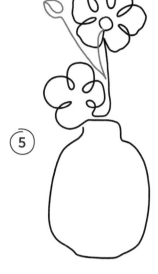

⑤

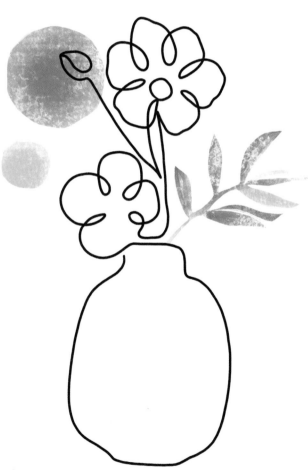

CUPCAKE

A sweet cupcake always makes for a delightful birthday treat, especially when it's adorned with sprinkles and candles. Why not turn this one-line drawing into a perfect birthday card for a loved one?

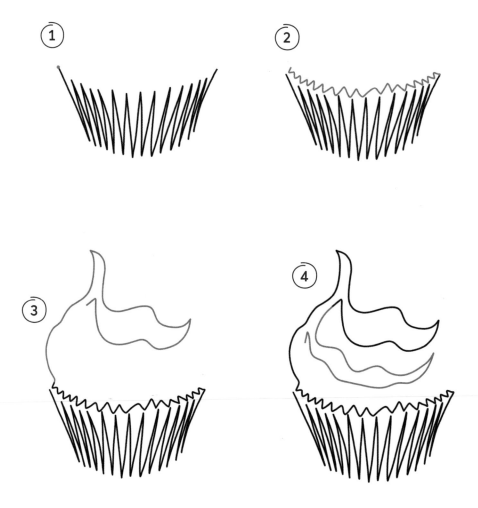

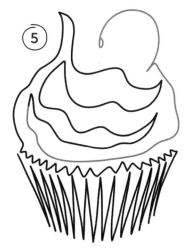

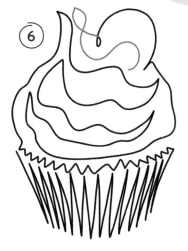

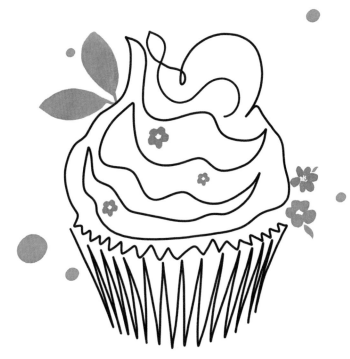

Still
Life

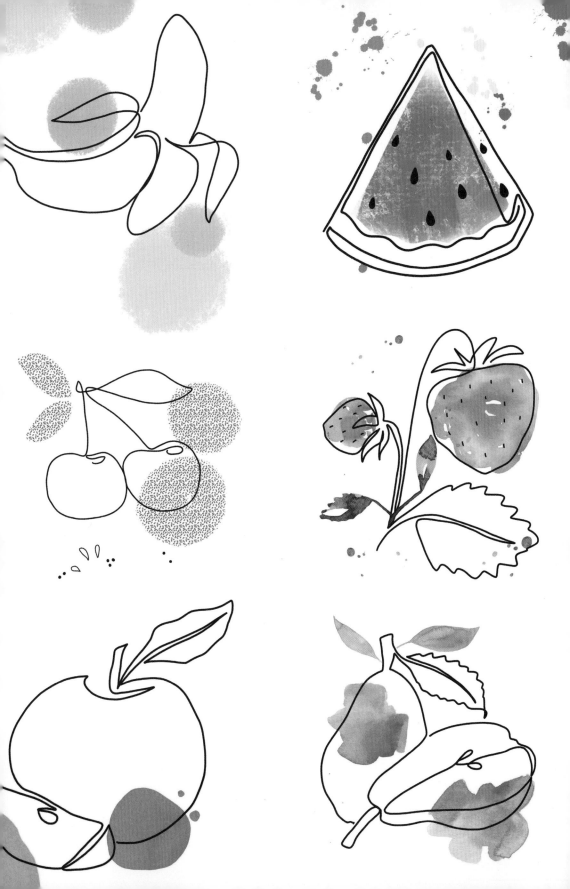

WATERMELON

Watermelon may be the most popular type of melon.
It's especially delicious during the summer! Pair your one-line drawing
with a piece of cardstock for a festive summer card or gift tag.

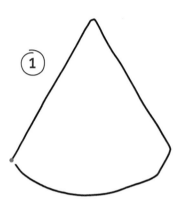

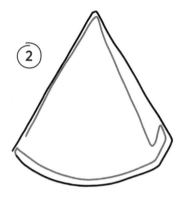

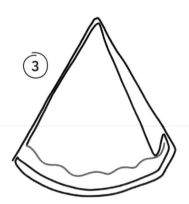

④

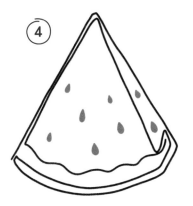

⑤

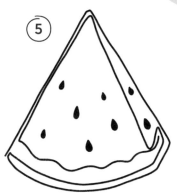

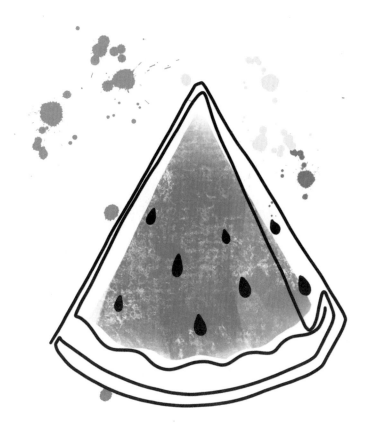

CHERRIES

Cherries are simply a wonderful fruit. I love their taste, whether they're fresh from the tree or baked in a pie. They're also one of my favorite objects to draw. Here I've made a digital background using Procreate®. Digital backgrounds work well with one-line art.

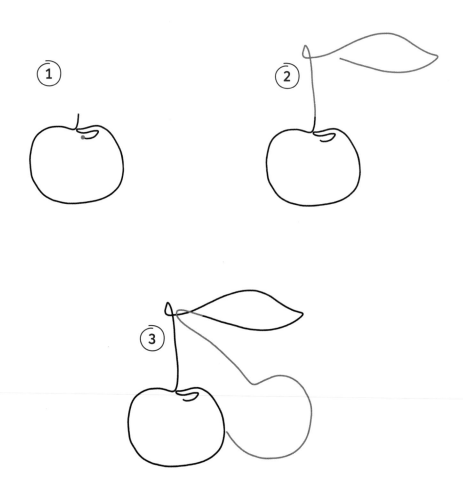

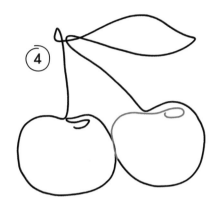

(4)

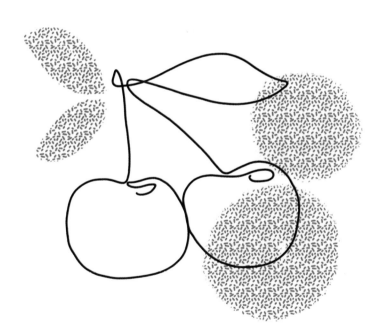

BANANA

I love this versatile and healthy tropical fruit
with granola, in a fruit salad, or simply on its own.
Banana bread is delicious too!

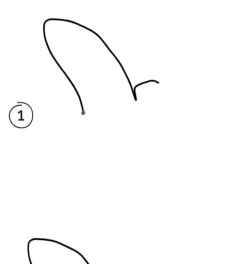

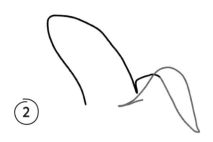

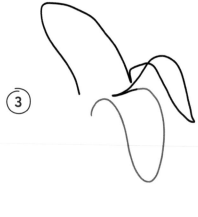

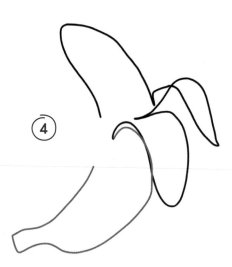

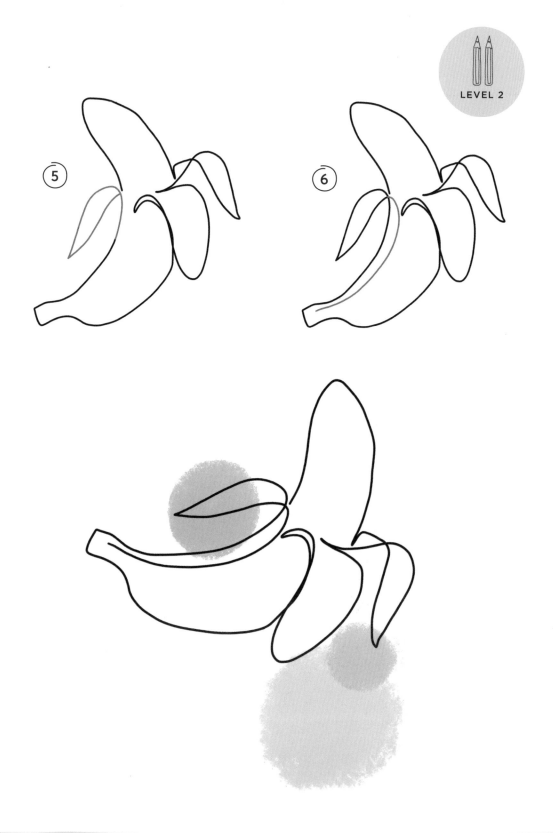

STRAWBERRIES

Doesn't it sound lovely to walk through a field of strawberries, picking the sweetest-smelling ones? Use your fresh-picked strawberries to make jam, and then decorate the jar with a ribbon and handmade card. You've just made the perfect little gift to bring to the next party you're invited to!

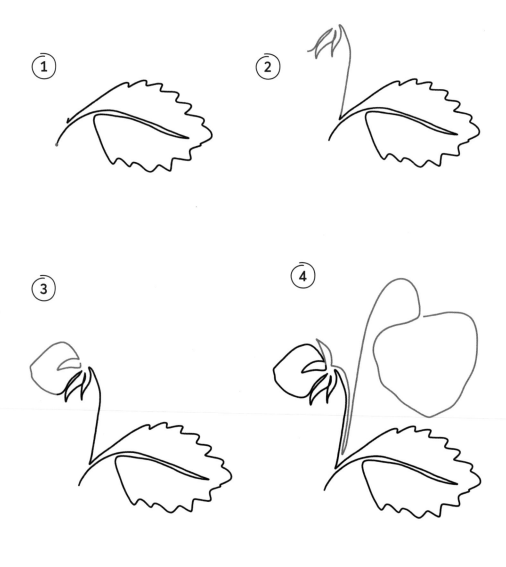

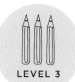
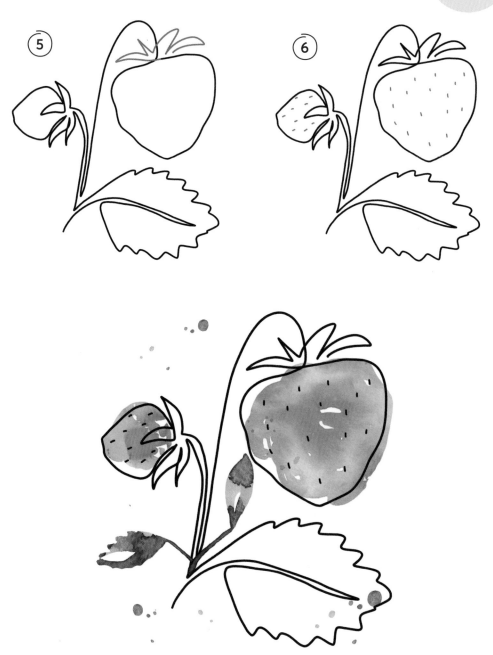

⑤

⑥

APPLE

Apples are typically harvested in the fall. That's also my favorite time to be an artist, when the leaves are changing outside and I can draw cozily inside.

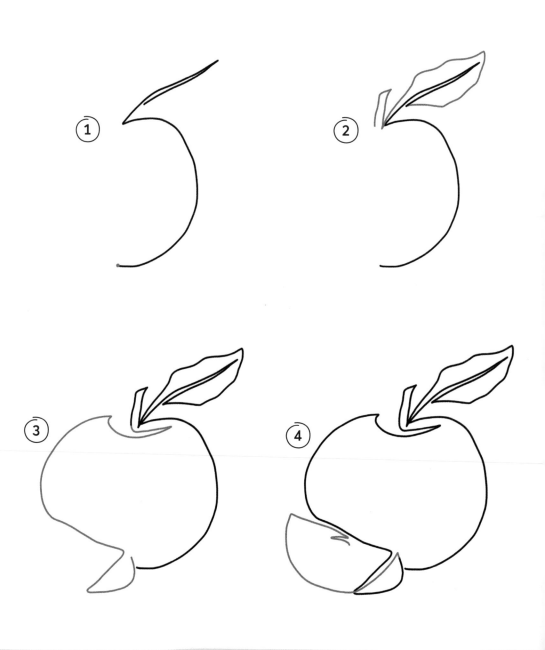

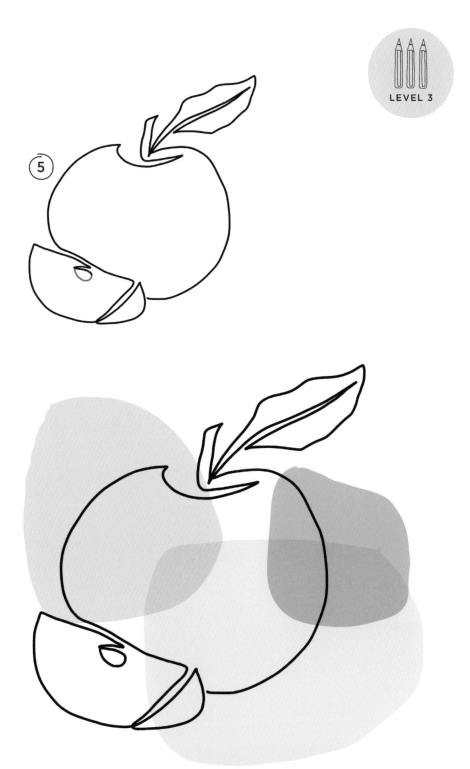

5

PEAR

Pears are perhaps not the trendiest of fruit, but with a one-line drawing and a colorful watercolor background, they make a very cool motif. And they're delicious too!

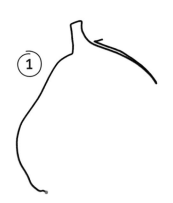

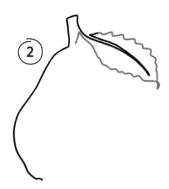

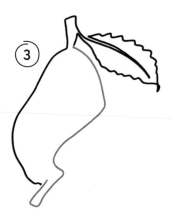

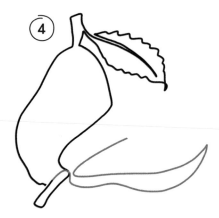

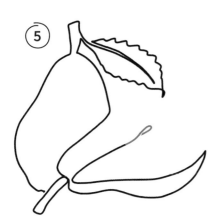

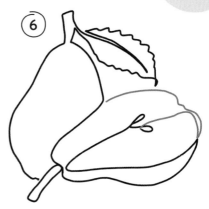

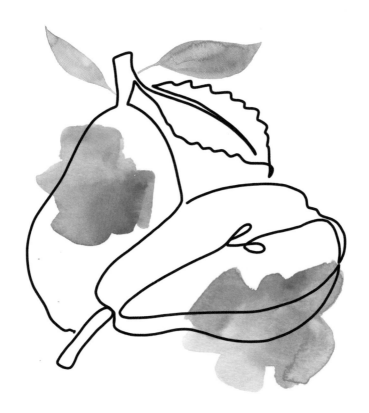

Celebrations

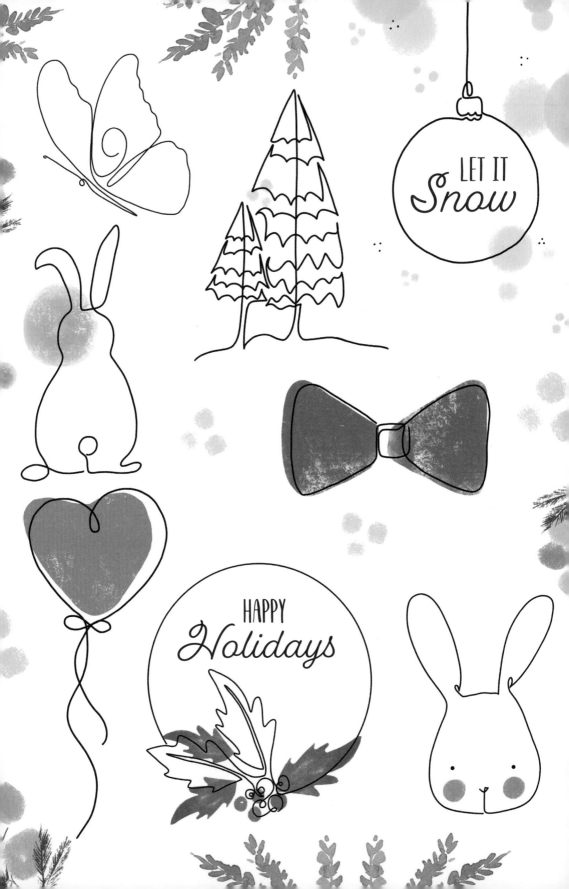

LET IT Snow

HAPPY Holidays

DREAM BIG, LITTLE ONE

A hand-drawn picture is a very personal and lovely present for
a birthday boy or girl. Add some color and a frame to bring
lots of joy to a beloved young one.

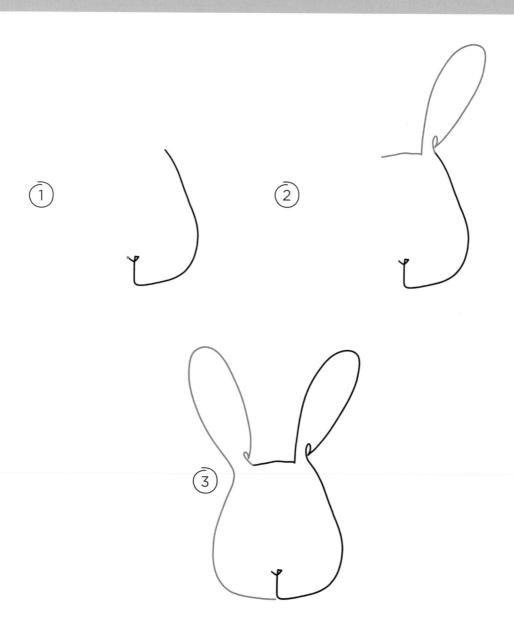

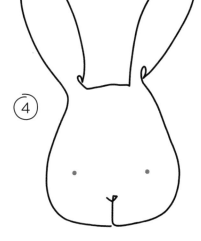

(4)

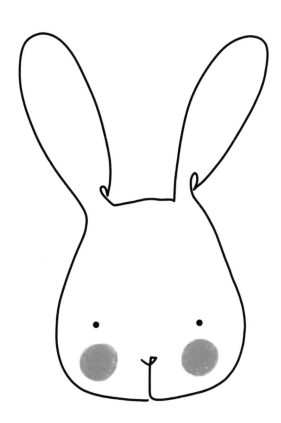

VALENTINE'S DAY

Every year on February 14, people give the ones they love flowers, chocolates, or other little signs of affection. Why not create your own card this year and give it to your Valentine?

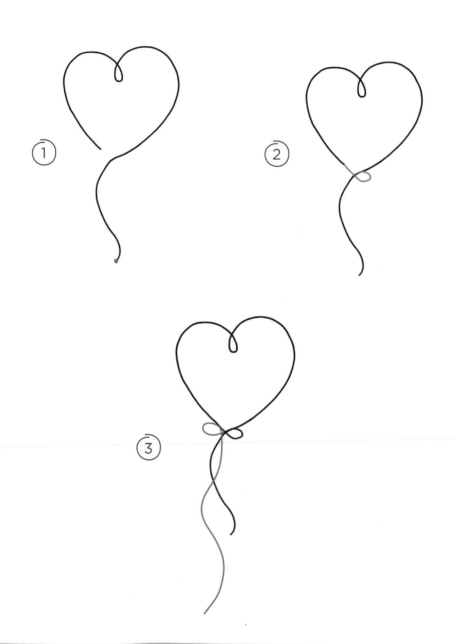

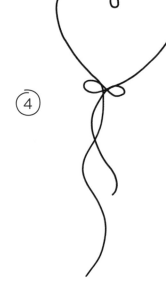

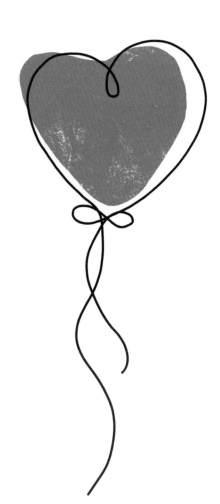

4

EASTER

I have many happy memories of spending Easter with my entire family. We'd hunt for brightly colored eggs in the yard and eat delicious baked goods, as well as chocolate rabbits.

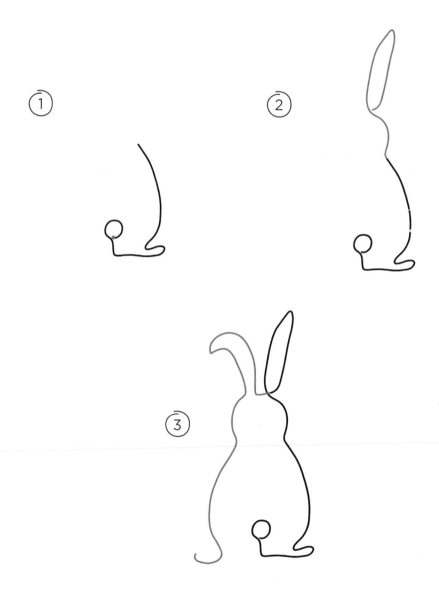

LEVEL 1

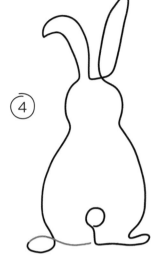

④

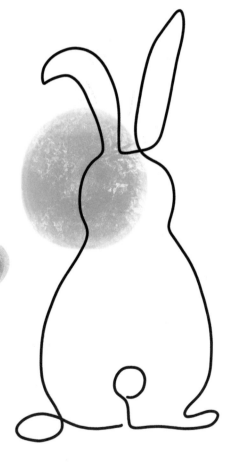

MOTHER'S DAY

Mothers, you are wonderful! This Mother's Day, add a pretty butterfly, watercolor blooms, and a sweet saying to the perfect Mother's Day card for your mother or any maternal figure in your life.

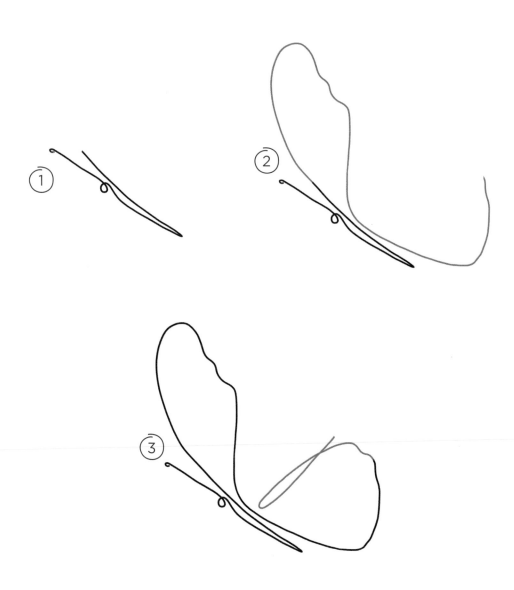

LEVEL 2

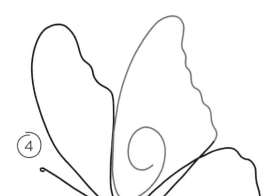

④

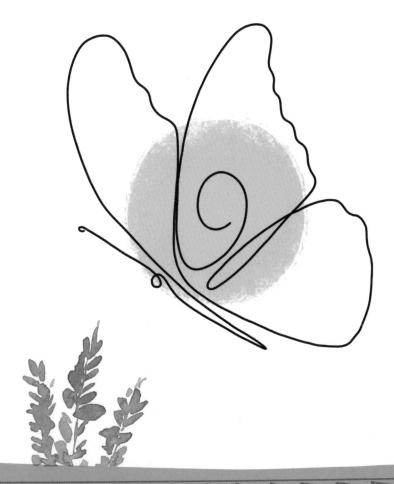

FATHER'S DAY

We can't forget the dads on Father's Day as well!
Wish your father well on his special day.

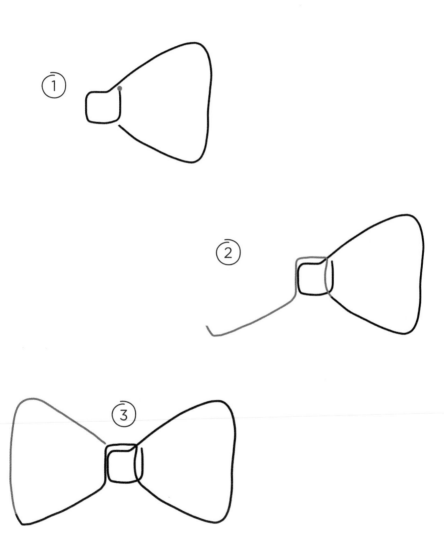

④

WINTER WONDERLAND

Winter is the time to stay home. Cuddle up inside with warm
socks, candles, and tea. It is also a great time to be creative
and design an idyllic one-line winter landscape.

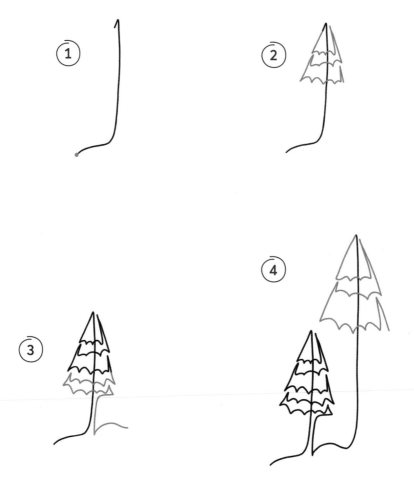

⑤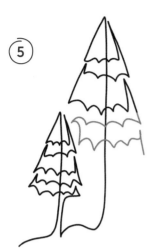

⑥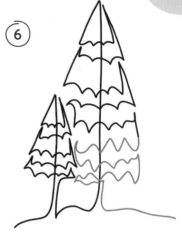

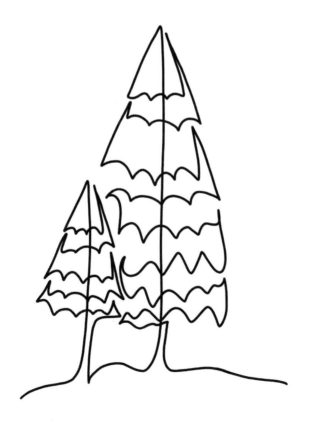

LET IT SNOW

Greetings and good wishes for the holiday season work wonderfully with one-line art. Give your handmade card a special look, and it makes a great addition to any holiday gift.

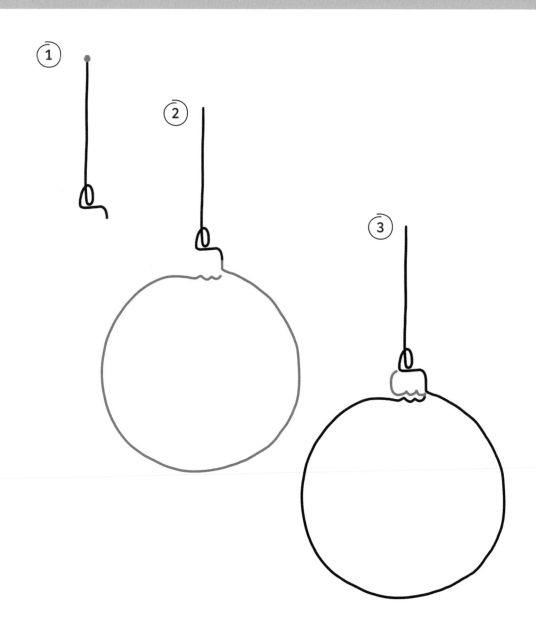

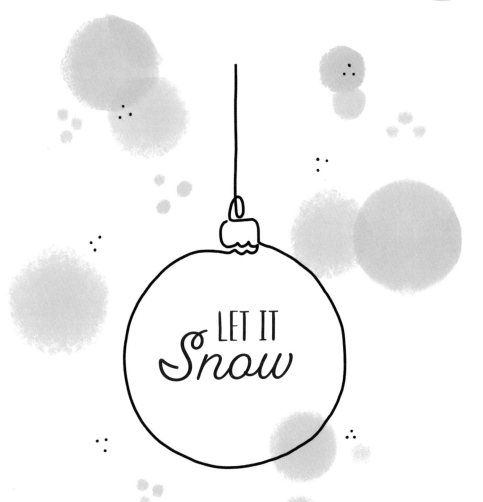

LET IT Snow

HAPPY HOLIDAYS

For many people, the holiday season is the most enjoyable time of the year. Decorate your home with lights, bake cookies, and get together with your loved ones. Try making your own cards next year!

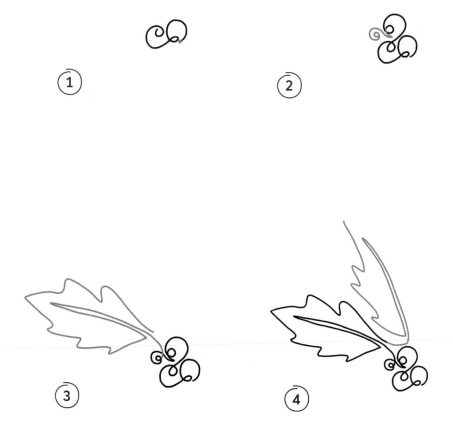

LEVEL 3

5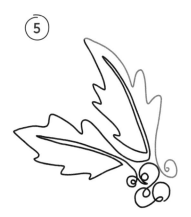

6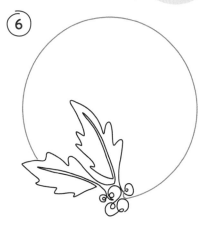

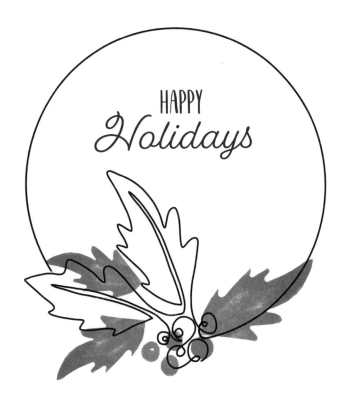

HAPPY
Holidays

KEEPING A SKETCHBOOK

When I go walking in nature, I always bring my sketchbook with me. Often, I'll take it into the garden for a few quiet minutes. Drawing outdoors gives you a totally different creative process.

With the help of a sketchbook, you'll expand your view of the world. It's your own moment that you experience and remember, like with a diary. A sketchbook is very personal—or at least that's how I see it. I give serious thought to which pages I choose to share with other people.

In your sketchbook, you're drawing only for yourself. You are making your own individual observations, free from judgment from anyone else. You don't need to aim for perfection. Your sketchbook is a place to let go of the fear of making mistakes. Mistakes are important and will help you continue to grow and develop.

Even when you only have a small window of time at your disposal, that's enough for a quick line drawing. Get a sketchbook and writing instrument that fit in your pocket. Try to capture a one-line drawing in your sketchbook every day. Give yourself completely and totally over to your artwork as you draw. Your observational abilities and concentration will improve. Don't forget: your drawing style will continue to develop.

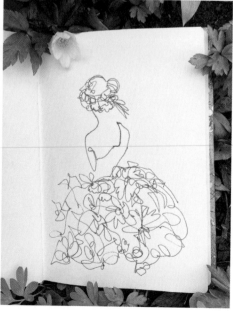

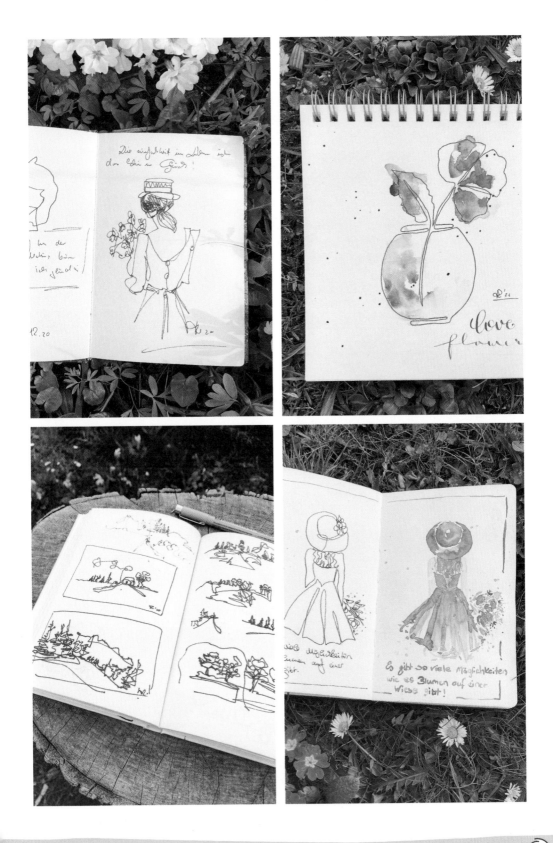

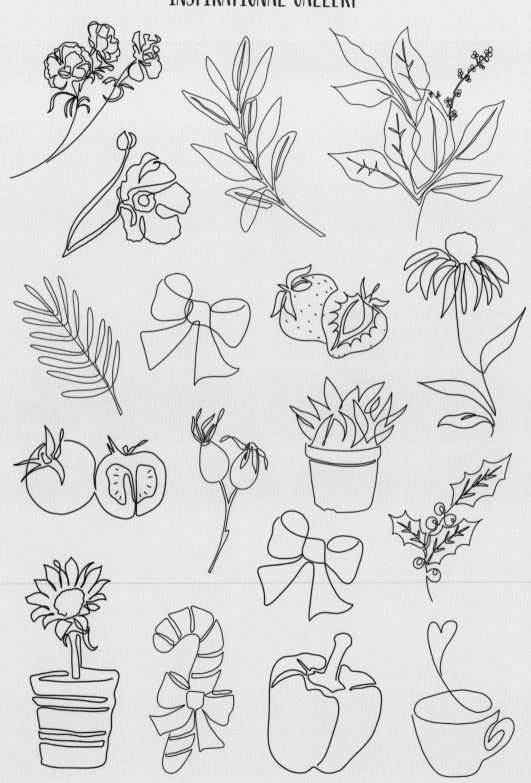